Haunted
Anchor Bay,
Michigan

HAUNTED ANCHOR BAY, MICHIGAN

DEBI CHESTNUT

Haunted
America

Published by Haunted America
A Division of The History Press
Charleston, SC
www.historypress.net

Front cover image: author's collection.
Back cover images: author's collection.

First published 2017

Manufactured in the United States

ISBN 9781625859884

Library of Congress Control Number: 2017945013

This book is dedicated to my husband, Lonnie, for his continuing patience and understanding; the people of the New Baltimore Historical Society for their continued encouragement and support; and my favorite breakfast place, Benvenuto's, for taking care of me and never letting me run out of coffee while I'm writing.

CONTENTS

Preface 9
Introduction 13

1. Haunted Objects 17
2. The Possessive Ghost 23
3. The Ghosts of the Grand Pacific House 26
4. The House on the Hill 35
5. Oakwood Cemetery 44
6. Lost Cities and Spirits 51
7. Shipwrecks, Ghost Ships and Other Great Lakes Mysteries 58
8. The Glowing Tomb 67
9. Memphis Cemetery 70
10. Morrow Road 72
11. Protecting the Innocent 75
12. The Haunted, Haunted House 79
13. Haunted Shorts 82
14. Unseen Resident 87
15. The Haunted Restaurant 91
16. Cryptids and Other Strange Creatures 94

Epilogue 99
Bibliography 103
About the Author 104

PREFACE

Welcome home. We've been waiting for you.

Those were the first words I heard when I stepped inside the all-but-abandoned mansion known as the Hatheway House, or the House on the Hill. I was new to the Anchor Bay area, having just moved there a few short weeks before the fateful day a new friend introduced me to the area. Those words changed my life.

I've been a ghost hunter for decades, and the Anchor Bay area is like nothing I'd ever experienced in my life as a paranormal investigator and a psychic medium. Certain locations along the shores of Lake St. Clair seem to crackle with spirit energy to the point that it can almost become overwhelming.

While I've always had an interest in local history no matter where I've lived, no place has sparked my interest more than this area. Many people here seem to embrace their history and the ghosts from the past in a loving, caring manner and would rather live with their phantoms instead of having them leave. It's as if the loss would be too great to bear.

A lot of people in the Anchor Bay area have also embraced me for who I am and have accepted my ability to see and talk to spirits in a positive and matter-of-fact way. This, too, is something I'd never experienced. I hid my gifts for years because, according to my mom, what I did wasn't "socially acceptable." However, looking back, I think she did it to protect me from people thinking I was mentally ill or some kind of freak. Even now, I still run into the haters and must face the prejudice of narrow-minded people

who don't believe in or understand exactly what I do. Some of them think I'm a freak because I don't fit into their closed view of the world or with their religious beliefs. I know this because a few of them have been bold enough to say it to my face. I've learned there's no point in arguing with these people; it's kind of like hitting your head against a brick wall, because it feels so good when you stop. I'm not one to force my beliefs on other people, and in return, I ask that they not try to impose their beliefs on me. Live and let live, I say.

It's been my experience that history and paranormal investigating go hand in hand. Almost every ghost has a story to tell about the past—how they lived, how they died and everything in between.

Knowing the history of a place—discovering information about who lived there, who died there and the events that took place at a specific location—can oftentimes tell you a lot about who the spirit and/or sprits are that haunt that house, building, cemetery or church.

Most ghosts and spirits generally haunt a place they loved when they were alive, or they linger around their friends and relatives who have yet to pass on to their own eternal slumber. They do this for many reasons. Sometimes, they have a message they want to deliver. In other cases, they may be there to help a loved one move on after they've passed or, in some circumstances, protect the living from something they perceive may be a threat. The reasons can be as varied as the ghosts themselves, and every haunting is different.

After being in the Anchor Bay area for about a year and discovering not only the history, but also the ghosts of the area, my friend Linda and I wrote *Ghosts of Anchor Bay*. It chronicled some of the interesting encounters we'd personally experienced.

That book ignited my writing career, and I went on to compose four more books about the paranormal: *Something Wicked, Stalking Shadows, So You Want to Be a Ghost Hunter?* and *How to Clear Your Home of Ghosts and Spirits*.

Which brings me to this book, *Haunted Anchor Bay*. I wrote this book, not only because I desperately wanted to, but also because it was becoming almost impossible to walk down the streets of New Baltimore without someone stopping to ask me when I was going to write the sequel to *Ghosts of Anchor Bay*. So, to all those people, I thank you for your encouragement and interest in learning more about the history and ghosts that roam the streets beside you, even when you're not aware that they are there.

Welcome home.

As usual, it was quite an exciting experience researching and gathering additional information and stories for this book. Some of the tales you may recognize from other books, but there is updated and current information included in them—for example, how Mabel Hatheway Dunham died and the journey her body took before she came to her final resting place at Oakwood Cemetery.

Speaking of Oakwood Cemetery, there is some updated information about that place, which, of course, revolves around the Hatheway family and why lily of the valley may have been planted on Mabel's grave so long ago and continues to bloom to this day.

As some of you may notice, I've changed publishers and am now with The History Press. Due to their publication guidelines, I can't relay a lot of the individual experiences I've had at the locations in this book, because the focus is on the history behind the hauntings.

Another momentous change is that I'm allowed to use pictures! I can't tell you how excited I am about being able to give you, the reader, the opportunity to see a location not just through words, but also through visual aids. However, The History Press does not publish pictures of ghosts, phantoms or other anomalies inside the printed pages of this book. So I've set up a website, HauntedAnchorBay.com, to show you the photographs and share my firsthand experiences at some of the locations included in this book that the press wouldn't let me use.

Personally, the biggest takeaway for me while researching and writing this book is that we need to fight to preserve the historical locations in the area we still have—those that have not been torn down to make way for "progress" or victimized by the greed of money-grubbing investors who don't care about the history of a location and aren't interested in preserving the past. We can't sacrifice our history and historical locations for the sake of small-town politics or allow people in power to manipulate the system to their advantage. We need to demand better of ourselves and of our leaders. And, indeed, some investors are buying historical buildings and preserving and repurposing them to fit into modern society without sacrificing the past. Bravo! We should applaud these forward-thinking people, support their efforts and frequent their businesses.

Another thing I noticed while researching locations for this book is that many cemeteries are falling into disrepair and, in some cases, falling prey to vandalism. Some of these cemeteries hold veterans of the Civil War and other wars. Not to mention the brave forefathers who came to this land, once wilderness, and forged their lives, built cities and made

it possible for us and generations to come to live in this beautiful area known as Anchor Bay.

More effort needs to be put into preserving these cemeteries, repairing the tombs and grave markers and keeping the history alive. Okay, I'm jumping down from my soapbox now.

In closing, I would also like to say that many of the names in this book have been changed at the request of those who own certain properties or have spoken to me in confidence. A writer always protects her sources. Some of the locations are not named or have been deliberately masked at the request of the owners of the homes or businesses.

Welcome home. We've been waiting for you.

Happy Hauntings,
Debi Chestnut

INTRODUCTION

Anchor Bay is located in the northeast corner of Lake St. Clair. The large bay, along with the rest of Lake St. Clair, has played a big part in this area's history.

The lake itself joins the Detroit River to the St. Clair River and is the smallest body of water in the Great Lakes system. One of the things that is so interesting about Lake St. Clair is that you can get literally anywhere in the world by water from here. This is possible because it helps connect all of the Great Lakes together.

While the lake may be small, it has a long history of being internationally significant in the shipping of many products and resources to other parts of the United States and the world. During Prohibition, the lake, because of its location between southern Ontario, Canada, and southeast Michigan, became a hotbed for rumrunning and the transport of other illegal alcoholic beverages. Many of the towns along Anchor Bay gladly participated in such activities.

Long before the French discovered this area, it was visited frequently by Native Americans. Some of the many Native American burial sites that have been studied date back to 9000 BC. In the 1960s, Dr. James Edward Fitting from the University of Michigan excavated a Native American site and wrote extensively about his findings. It was his belief that the Native Americans came to this area to bury their dead, not so much to live here. In addition, he noted that many archaeologists have theorized that some tribes traveled for weeks, even months, to get to this area, not only to bury

their dead, but also to hold a ceremony that may have been the precursor to the Feast of the Dead celebrated by many Native Americans in the seventeenth century.

Archaeologists who have excavated several different sites in the area found that some of the skulls had circular discs removed, and the skulls were packed with clay. Some of the burials were found to have extra skulls that were often placed close to the waist area of the skeletons. It is surmised that perhaps these skulls were part of a belt that was worn by the deceased as if they were trophies.

The Anchor Bay and Lake St. Clair area remained pretty much untouched except for the Native American presence until it was discovered in 1679 by French explorer Robert de la Salle, Father Louis Hennepin and thirty-one crew members aboard the *Griffon*, which had set sail from Niagara Falls in search of new territory. While some historians disagree about how the lake was named, it's generally thought that the lake was named in honor of Saint Clara of Assissi, whose feast was celebrated on the same day the lake was discovered.

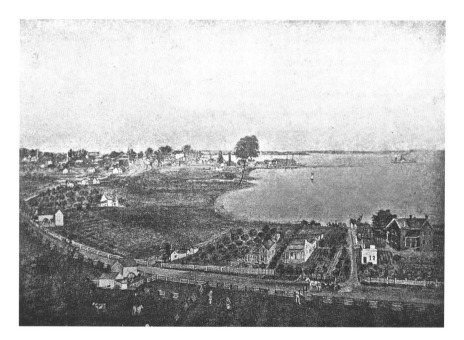

Artist rendering of New Baltimore and Anchor Bay in 1877. *New Baltimore Historical Society Collection.*

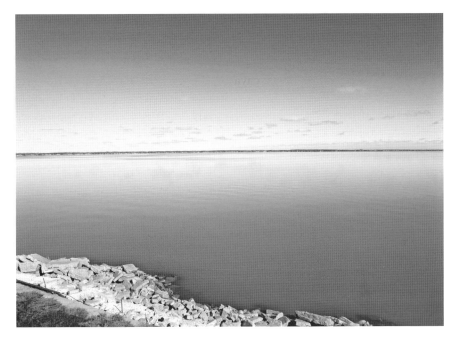

Anchor Bay looking from south to north. *Author's collection.*

However, long before this, Lake St. Clair went by many different names by various Native American tribes. The Mississaugas, who by the late seventeenth century had established a village by the lake, called it Waawiyaahtaan, meaning "at the whirlpool."

The early French mapmakers used a variety of French and Iroquois names that included, but aren't limited to, Lac des Eaux de Mer, which means "seawater lake," and Lac Ganatchio, meaning "kettle," because of the shape.

Other Native American names for Lake St. Clair have to do with things that are sweet, because the lake is fresh water and not salt water. Those names include Otsikea, Kundequio, Oiatinatchiketo and Oiatinonchikebo, all roughly translating into words having to do with candy or other sweet treats.

Over time, the Native Americans were moved to three reservations along the Anchor Bay coast and, eventually, either to the Trail of Tears or to Canada. Many Native American burial sites have been destroyed, although steps have been taken to protect some of the burial grounds. There may be Native American sites that have yet to be discovered.

Over a brief period of time, the area became settled, and the town of New Baltimore became a major shipping port on the Great Lakes that further boosted the economy and settlement of the Anchor Bay region.

While Lake St. Clair is still a crucial shipping channel on the Great Lakes, it is now widely known as a favorite boating destination and a fisherman's dream.

From a paranormal perspective, some may say that the Anchor Bay area is the "perfect storm." There are large bodies of water, Native American burial grounds and a couple of major ley lines running through the area. Some, if not all, of these characteristics could be large contributors to the abundance of paranormal activity in the area.

Many of the people who live or at one time lived in the Anchor Bay area don't seem at all surprised by the amount of paranormal activity. In fact, they would be more surprised if no ghosts or spirits returned to the area after they passed on.

One resident summed it up like this: "Who wouldn't want to come back here? The area is so rich with history and such a beautiful place to live that a lot of people who've moved away still long to return to the area someday. There's something about this place that gets in your blood and stays with you your entire life."

That pretty much sums up why so many ghosts and spirits may choose to return to the Lake St. Clair area, and this probably explains it better than any of the fancy explanations some paranormal investigators offer up to explain the plethora of paranormal events in the region. It's simply a fabulous place to work, live and, apparently, haunt.

1
HAUNTED OBJECTS

For years, haunted objects have been a source of fascination for paranormal investigators and others.

An object with a spirit attached to it can come into someone's life in many ways. Sometimes, they are purchased at an antiques store, flea market, garage sale or thrift store by an unsuspecting customer. Other times, they are inherited from a relative or come into their life in other ways. How they get there isn't really that important. What really matters is that once they are there, havoc and/or chaos often ensue.

SOMETHING IS CAVORTING, BUT IT ISN'T NYMPHS

Take the case of a print by Jean-Baptiste-Camille Corot called *Dance of the Nymphs*. It was purchased at an antique fair for $1. The fact that the print, which is worth well over $100, was so inexpensive should have raised eyebrows and a lot of questions, such as: Why was the framed print being sold for such a low price? But no one asked. Mary Benning was so excited to get such a good deal, she didn't think to ask about the pedigree of the print.

Once she got it home, she hung it in the upstairs hallway next to her linen closet. A few days later, she walked upstairs to find all the items from the linen closet stacked neatly on the floor in the hallway. Not long after that experience, as she was heading to bed one night, she reached up for the long

pull chain for the hallway light, but it wasn't in its usual place. Mary looked up and saw that the chain was neatly wrapped around the light. The ceilings in her old Victorian home are very high, so there's no conceivable way the chain could have become wrapped around the light unless someone or something did it intentionally. Mary's husband fetched a ladder to unwrap the chain. She removed the picture from the hallway and rehung it in the large upstairs bathroom.

Mary's daughter, who is not prone to flights of fancy, came home from college and was taking a shower. She heard someone pounding rather forcefully on the bathroom door. Thinking it was one of her parents, she yelled that she'd be right out, but the pounding continued. When she peeked out of the shower, she saw that the door knob was turning back and forth, as if someone was trying to get out—or in. She got out of the shower and looked around the house, but no one was home, save for the cat lounging peacefully on her bed.

When her parents got home, she related the strange events to her mother, who decided that enough was enough. She offered the print to a friend of hers with a warning about the paranormal events surrounding the picture.

Framed haunted print of *Dance of the Nymphs*. *Author's collection*.

Mary's friend Victoria gladly took the print and hung it above her bed. It was then that Victoria began to have weird dreams, which at times incorporated visions that appeared to be scenes out of someone else's life. The dreams feature people she doesn't know, and the events take place in a different place and time in history, most likely the late 1800s.

Victoria also reported that, sometimes, the dreams turn into nightmares, but not the type of nightmares that don't make any sense. Rather, these nightmares are extremely realistic. They usually revolve around a specific event, such as a fire, sickness or death. As morbid as it sounds, it's possible that the spirit is simply trying to share the story of what they experienced and/or witnessed in their own life and how they felt when these events took place.

People who have owned this print have reported that their dog will, at times, take a defensive posture and bark at someone or something no one else can see. In addition, there have been reports of objects being rearranged on dressers, in cabinets and in other places around the house. Nothing is ever broken or thrown, just rearranged. There is never, in this case, a logical explanation for these types of occurrences, other than that it all started when this print came into their lives and ended as soon as the print was out of their possession.

Old Bed Can Count to Thirty-six

In 1955, it was reported that the Stoner family of New Baltimore, Michigan, had a bed that, at night, started pounding out numbers, causing the family to suffer from many a sleepless night. While they'd owned the bed for a few years, the family reported that in the last several months, the bed has started counting. It does this by gently starting to vibrate, and then the sound varies from a gentle tapping to a violent pounding.

The Stoners and the police department were dumbfounded by this activity. At times, the bed will even pound out answers to specific questions that involve numbers. The family's neighbors have been summoned over and they, too, have witnessed the strange phenomenon.

While Mrs. Stoner has been understandably concerned about this activity, the family's three children became accustomed to the racket and have been able to sleep through most of it.

About the activity, Mr. Stoner said, "I wish whatever it is would get up and walk around so we could see what it is and be done with it. This way we don't know what is going on."

Donald Hornbrook, a New Baltimore police officer, couldn't explain the activity, either. He patiently sat with the family one evening for three hours. Officer Hornbook reported, "I could hear the pounding very plainly. It even counted as high as 36. I checked all around the inside and outside of the house but found nothing. It's baffling."

Yet when a group of three officers from the New Baltimore Police Department sat with the family one night, the bed didn't make a sound. The family wasn't put off by the lack of activity and was convinced that whatever caused the bed to count would eventually return.

It should be noted that the Stoner home didn't have a basement, and the only crawl space was under the raised floor of the utility room, not the bedroom where the bed was located. The Stoners weren't deterred by the strange events and refused to take down the bed or get rid of it. They decided to ride it out.

If the bed is still in existence, the current owner is unknown as of this writing.

THE OUIJA BOARD

The debate about Ouija boards has raged for over a century. Some people insist that the Ouija board is a harmless toy. Others claim that it's capable of opening the door between the worlds of the living and the dead, allowing any type of entity, good or evil, to pass through.

It's hard to ignore the sheer number of stories throughout the years relating to the Ouija board. While most of the tales about phenomena occurring while using a Ouija board are interesting, a story this author heard about while researching this book is fascinating. I can't validate the facts of the story, so make of it what you will.

A few years ago, Jenny and Pete were at a flea market in the Anchor Bay area and impulsively purchased a Ouija board from one of the vendors. They took it home and used it a few times, with mixed results. The board ended up being put on a shelf in the hall closet and basically forgotten about until Jenny and Pete decided to move into a new home.

Like so many other people do when they're getting ready to move, Jenny and Pete cleaned out closets, drawers and the rest of the house to have a garage sale. The Ouija board was marked with a green three-dollar price tag and put out for the sale. By the end of the day, most of the items were gone, the Ouija board included.

You might think that this would be the end of the story, but it isn't. Several months after moving into their new home, the young couple began to experience some paranormal activity. Occasionally, doors would open and close by themselves and lights would blink on and off. Sometimes, they would hear footsteps on the basement stairs.

Jenny and Pete figured they had some type of ghost sharing their space. It really didn't bother them all that much, because they never felt threatened by the presence and the activity wasn't that frequent.

One day, Jenny was in the basement going through some plastic containers holding items they hadn't unpacked yet when she came upon a Ouija board at the bottom of one of the containers.

At first, Jenny was confused. She knew they hadn't purchased another Ouija board, but her confusion turned to fear when she saw the green sale tag marked with "$3.00" on top of the box. She asked Pete about the board when he came home from work, but he swore he hadn't pulled the board from the garage sale. Jenny believed him because, for some reason, although she didn't know the person's name, she distinctly remembered the woman she'd sold the board to at the garage sale.

Jenny was so shaken up by the reappearance of the Ouija board that she donated it to charity along with several other items.

After some time, Jenny and Pete were expecting their first child and were cleaning out a spare bedroom to make room for the nursery. Tucked in between two blankets on the shelf of the closet, Pete found the Ouija board with the green three-dollar sticker on the top of the box.

Jenny and Pete became so disturbed at the sudden return of the Ouija board that they just wanted it out of their house and gone forever. After some research, Pete and Jenny decided to break the Ouija board into exactly seven pieces, sprinkle it with holy water and bury it.

On a trip to northern Michigan the next weekend, Jenny and Pete found a peaceful place in the woods that seemed appropriate. Pete dug a rather deep hole and buried the Ouija board. This was several years ago. To date, the Ouija board hasn't shown up again…and if it has, Pete and Jenny have yet to find its hiding place. At last report, all paranormal activity in their home has ceased.

Jenny and Pete's story is not the first that claims a Ouija board has returned to its owner time and time again, and it certainly won't be the last.

Another story from a different state claims that another couple was in the same situation that Jenny and Pete found themselves in. This couple,

however, after reading so many different opinions on how to properly destroy a Ouija board, gave it to a friend who owned a store that specialized in oddities. Their one condition to letting him have the board was that it remain in his store, never to be sold. As far as anyone knows, the Ouija board still resides in the store.

The Haunted Radio

A few years ago, in a small antiques store that has since closed its doors with the owner's retirement, Amelia purchased an antique radio because she thought it would look perfect in her family room. She was excited to find that, when she plugged it in, the radio still worked.

Her excitement soon turned to bewilderment when strange things began to happen in her Chesterfield Township home. Much to Amelia's dismay, the radio would turn itself on and off at several times during the day. Because she lived alone, Amelia knew that no one else but her could be turning the radio on.

She thought that perhaps the radio had a malfunction. She took it into a repair shop, but according to the personnel, the radio was in perfect working order. It just needed to have the inner workings cleaned, a job which they performed. Thinking that would solve the problem, Amelia picked up the radio and, when she got it home, plugged it into an outlet in the kitchen. She surmised that perhaps the outlet in the family room was faulty, but the radio continued to display the same behavior.

Amelia returned to the antiques store and asked the owner if he knew who had owned the radio before her, careful not to disclose how the radio was behaving. The owner told her that he'd purchased it at an auction and really didn't know anything about it.

Discouraged, Amelia returned home more determined than ever to figure out the mystery of the radio. She even went so far as to call out an electrician, who confirmed that the electrical system in her house was in perfect working order and that there weren't any faulty plugs or wiring. Yet the radio continued to play on.

While at times the activity unnerved her, she became accustomed to waking up to the sound of music from the radio. After a few weeks, Amelia resigned herself to the fact that she had a haunted radio. She knew she could easily dispose of it, but since she never felt threatened by the ghost or spirit that had attached itself to the radio, she decided to keep it. As of this writing, Amelia and her radio are still cohabitating and seem to be at peace with each other.

2

THE POSSESSIVE GHOST

Sometimes, a ghost can get possessive over what was theirs when they were alive. When this happens, it can lead to extremely interesting circumstances. Take the case of Captain Francois Marsac, who was born in Detroit in 1770 and later married Cecilia Saucier at Fort Detroit.

Around 1796, the captain started a settlement at Swan Creek, about four miles west of New Baltimore, Michigan. Around 1798, Captain Marsac started a settlement at Tremble Creek, a small stream off Ridge Road near New Baltimore. He purchased land from Pierre Yax on February 18, 1808.

It's widely believed, even today, that Captain Marsac managed to accumulate a significant quantity of gold bullion during his lifetime. Forced to flee because of Native Americans, legend has it that the captain buried his treasure about a mile from New Baltimore.

As a side note, and perhaps a clue for all you treasure hunters out there, an article appearing in the *Detroit Free Press* on September 21, 1921, states that two government land patents were filed on that date. They were both written on sheepskin that had yellowed with age, yet the black writing was still as clear as if it had been written that same day, September 21, and dating to the time of President James Madison.

The one found to be most interesting for purposes of this story was dated May 30, 1811, conveying a parcel of property to Barrabe Campeau, the assignee of which was Francois Marsac. The land patent covered more than four hundred acres on and near Lake St. Clair and stretched to Mack Road. The land patents were signed by the secretary of state at the time,

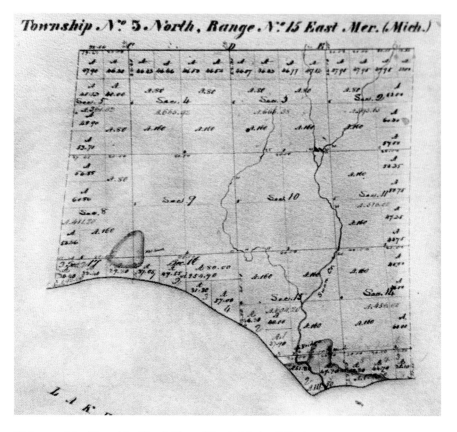

Old map of Ira Township. *New Baltimore Historical Society Collection.*

James Monroe. For more information on the land the captain owned, please visit https://glorecords.blm.gov/search/default.aspx and do a search for Michigan and use the last name Marsac. Happy treasure hunting!

History is not clear as to whether Captain Marsac was killed by Native Americans or died of exposure around 1811, but one thing is clear: the secret of where his treasure is hidden died with him.

Now here's where things get interesting. Many people have searched for the lost treasure of Captain Marsac, and some of those people and others believe that the ghost of the deceased captain so vigorously guards his treasure that he possesses the ability to move the treasure to a new location every time someone gets close to finding it.

Many paranormal investigators and others would find this story very intriguing, not because of the treasure, but because of the ghost allegedly being able to move his treasure at will to prevent it from being discovered.

Looking at this story from a paranormal perspective, it is possible that the ghost of the late captain is manipulating the treasure in such a way that it can't be found. I've personally witnessed objects being moved and/or thrown across a room by a spirit. In addition, many people have had objects mysteriously disappear only to show up in an obvious place days, weeks, months and even years after they've vanished. Therefore, the logical conclusion would be that, yes, this story is quite plausible.

So, the way I see it, there are two unanswered questions: Is the treasure still out there somewhere? Can you really take it with you after you die? The answers to these questions have yet to be discovered.

3

THE GHOSTS OF THE
GRAND PACIFIC HOUSE

The Grand Pacific House, now home to the New Baltimore Historical Society and Museum, was built by Frederick Losh in 1881. It originally was built to be a hotel that housed a lobby, saloon, dining room and eight guest rooms. After Mr. Losh's early death when he was in his thirties, his wife, Emma, took over the day-to-day operations. Their photographs are prominently displayed in the second-floor parlor.

Later, she sold the hotel, and it became a boardinghouse. The Grand Pacific House has also been a private residence, a soda fountain, a candy shop and a hardware store. Now it houses the New Baltimore Historical Society and its museum.

Like many historical buildings, the Grand Pacific House is not without its share of ghosts that roam the rooms and hallways of the old hotel. Some of the spirits seem to be attached to specific artifacts the museum holds, while others are attached to the building itself.

It's said that the deceased often return to places they loved or had an emotional attachment to when they were alive, and the museum is no exception.

Many believe that the spirit of Fred Losh or his wife, Emma, follows people up and down the stairs leading to and from the second floor. The feeling of someone being behind you can become so overwhelming at times that you can't help but look behind you to see if someone's there. Patrons of the museum and the volunteers who work there have also reported this activity.

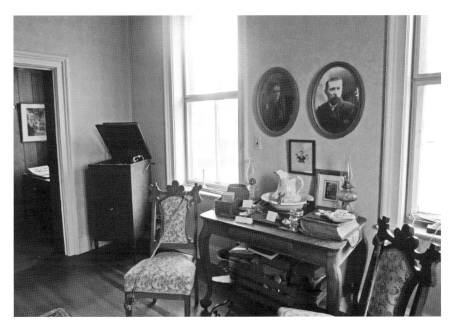

The portraits of the Loshes on the wall of the parlor in the museum. *Author's collection.*

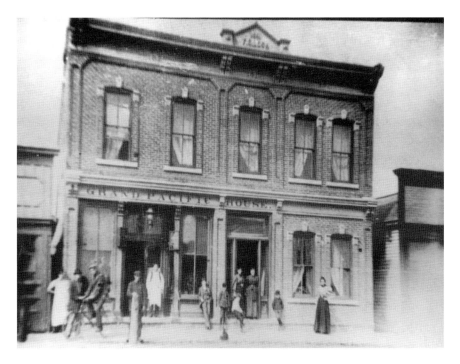

Grand Pacific House soon after opening. *New Baltimore Historical Society Collection.*

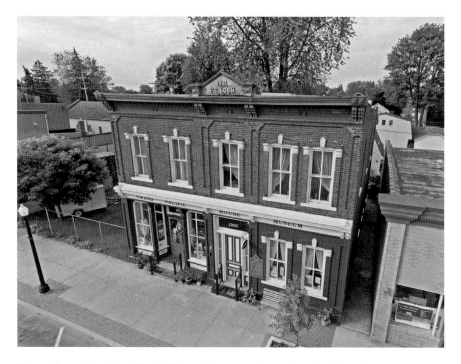

Drone view of the Grand Pacific House Museum as it stands today. *Vince Nestico.*

There have been numerous reports of Emma making her presence known in the museum. She's been known to touch people on the shoulder or arm, and some people have caught glimpses of her or her long skirts on the stairs and elsewhere in the museum. Emma's presence can be so pronounced at times that some people will call out a greeting to her when they enter the museum and say goodbye to her when they leave.

It's widely believed that Emma and Fred Losh aren't the only spirits that call the museum home. During one of the many paranormal investigations at the museum, a spinning wheel that was on loan to the museum was captured by video camera spinning by itself. There have also been reports of footsteps in the upstairs hallway or going up and down the stairs. These may, at times, be attributed to Emma and Fred. However, as one person stated, if you really listen to the footsteps, they're often different—more than one phantom is walking the floors.

Some people have said that the second floor of the Grand Pacific House Museum is the creepiest, because they almost always feel as if they are not alone, even if they are the only ones in the building. There is a feeling, they

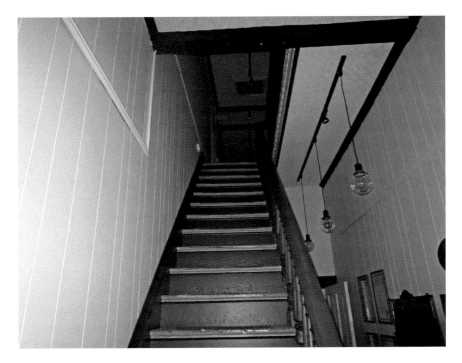

Haunted staircase in the Grand Pacific House Museum. *Author's collection.*

say, of always been watched, as if someone's eyes are upon them, watching every move they make.

People have also reported feeling particularly uncomfortable in the upstairs bedroom and in the kitchen on the second floor. No one this author has talked to can explain exactly why they feel this way, but it's obvious from speaking to them that the feeling stays with them long after they've left the museum. So much so that even the memory makes some people visibly uncomfortable.

The museum is home to an embalming table, located in one of the second-floor rooms. The table is folded and leans discreetly against a wall. Bricks from various homes and other historic places that have been torn down to make way for progress sit on the edge of the table. Some folks have indicated that the mere presence of the embalming table in the museum makes them uncomfortable—being in the room with the table is almost too much. Some of these people have reported a feeling of profound sadness and/or despair when in the presence of the table, while others say it "creeps them out."

The folded-up embalming tables with bricks from historical buildings on top of them. No wonder some people feel a little strange in this room. *Author's collection.*

It could be that the presence of the embalming table makes some people feel this way, but there have been so many reports involving the table that it's possible there's more to the story. It wouldn't be unusual for an object of this nature to absorb a lot of energy and retain that energy in some form. All that energy would have to go somewhere, and if it's being emitted into the room, it could trigger the experiences that many people are having.

It should also be noted that there are many life-sized mannequins on the second floor of the museum. The kitchen and especially the bedroom are home to more than a few dolls. Many of the mannequins are in the hallway, but there's one in the kitchen, as well. The bedroom that receives the most complaints is filled with dolls. Dolls and mannequins give some people the creeps, and this could explain the feelings that are experienced by some while in the museum.

Another possible explanation for some of the paranormal activity in the Grand Pacific House is attributed to a little girl named Anna. Her name was found carved into the windowsill of the second-floor office. During recent renovations, initials were found carved into a doorjamb. However, given the fact that they were carved sometime between 1881 and 1986, it's impossible to attribute them to Anna.

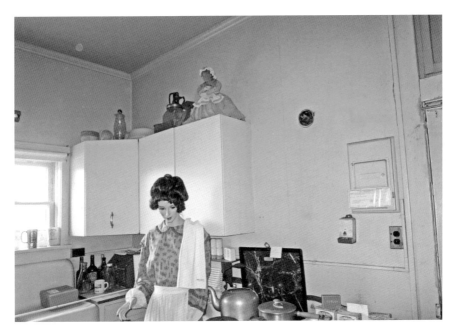

The kitchen in the Grand Pacific House Museum. People tend to get creeped out in this room. *Author's collection.*

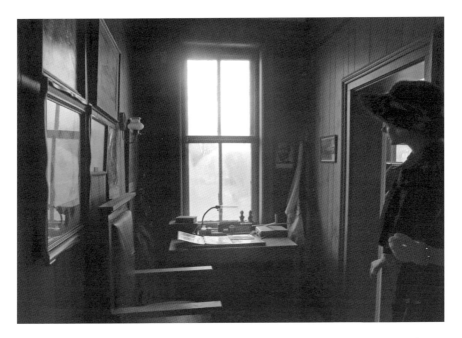

Upstairs hallway of the Grand Pacific House Museum. The mannequins catch a lot of people off guard. *Author's collection.*

The talk around the museum is that a little girl named Anna lived there at some point in time. Sadly, it's also widely believed that she died there while still a child. In the local cemetery, buried in a family plot lies the unassuming grave of Anna Neumann, who died in 1885 at the tender age of seven. As of this writing, there isn't any historical evidence that Anna died in the Grand Pacific House, or that Anna Neumann is the right little girl, but it's interesting to consider the possibilities.

It could also explain the feeling one gets in the upstairs bedroom. What little girl in the Victorian era could resist a beautiful bedroom filled with dolls and other wonderful items?

During a recent paranormal investigation, the investigators believe they may have been in contact with the playful Anna. While conducting an EVP (electronic voice phenomena) session with an EMF (electromagnetic field) device, which will light up if there is a change in the electromagnetic energy, the lights appeared when the investigators asked if any spirit was in the room with them. They then instructed the spirit to activate the lights on the device when they said the name of the phantom. Through a process of elimination, the investigators were able to determine that the spirit was

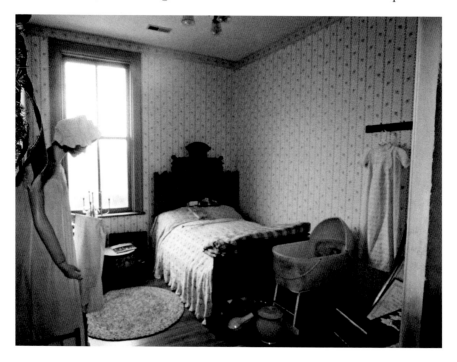

Anna's favorite place to play in the museum. What Victorian child wouldn't love to have this bedroom? *Author's collection.*

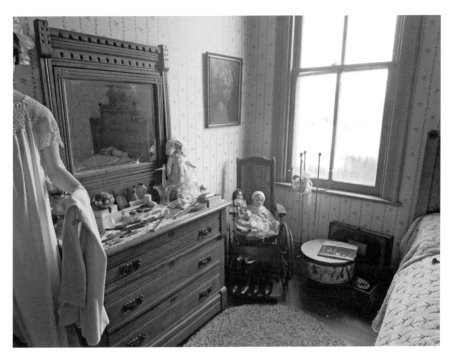

The dolls tend to make people uncomfortable in the upstairs bedroom of the museum. *Author's collection.*

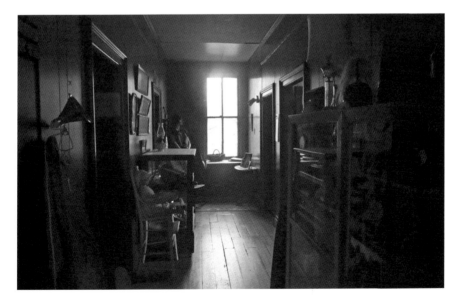

Before the extensive facelift in the upstairs hallway of the museum, many people felt as if they were being followed. *Author's collection.*

named Anna. While Anna quickly became bored turning the lights of the device on and off, a tape recorder running at the same time did pick up, for a brief moment, the sound of a child giggling. Could this have been Anna? It's impossible to know for sure.

Whoever the phantoms are that roam the halls of the Grand Pacific House Museum, they are engaging, friendly and, from all indications, enjoy interacting with the living.

4

THE HOUSE ON THE HILL

Although the legacy of the Hatheways began sometime around 1843, with Gilbert Hatheway's first visit to New Baltimore, what everyone remembers most is the house. Historical records are rather murky as to exactly when the house was built, but most historians agree that it was likely constructed between 1855 and 1857.

Of all the places in the Anchor Bay area, undoubtedly one of the most haunted was the Hatheway house, better known in the community as the "house on the hill." While the house is no longer standing, its legend continues and probably will for many years to come.

Gilbert Hatheway had been a colonel in the Massachusetts militia before coming to Michigan. A wealthy businessman, Mr. Hatheway made New Baltimore his home along with his wife, Abigail; son James S.P. Hatheway; daughter Isabella, who moved to Adrian; and son David, who was tragically lost while on a ship that was sailing around Cape Horn during a storm.

For the purposes of this story, we shall concentrate on Gilbert Hathaway, his son James, James's daughter Mabel and, of course, the house.

By all accounts, Gilbert Hatheway was a benevolent man. He donated land to the emerging German population so they could build a church. His only stipulation was that the building resemble a New England church. The structure still stands and is in operation to this day.

After a large fire almost burned the entire city to the ground, Gilbert Hatheway either donated money or gave business owners low-interest loans to rebuild.

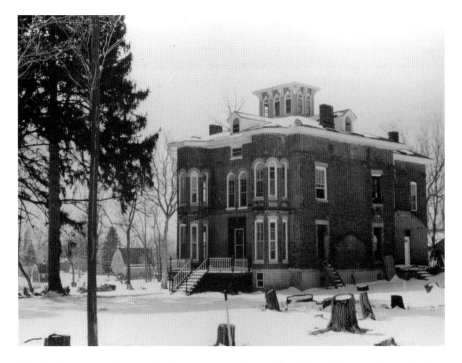

The Hatheway mansion soon before it was torn down. It's still possible to see how majestic it must have been in its day. *Author's collection.*

Because he suffered from severe and crippling rheumatoid arthritis, it had become too difficult to commute to his businesses in town. He soon purchased a home in the heart of the city, leaving his son and his family to reside in the large mansion. Gilbert Hatheway died in 1871, barely a year into his first term as a state senator. He was laid to rest in Oakwood Cemetery, just down the street from his glorious mansion. His wife, Abigail, followed him to the grave a few years later.

Perhaps one of Gilbert's greatest accomplishments was one that came into fruition after his death. He bequeathed $15,000 to the City of New Baltimore with the understanding that the money be used to build a school.

Gilbert's son James contested this passage in his father's will, taking the case all the way to the Michigan Supreme Court. James lost the case. He ended up having to give the city a sum of about $20,000, which included an estimate of the interest the money would have accrued during the legal battle. The Hatheway Institute opened in 1876 and accommodated students from grade school through college. A massive, three-story structure with a gymnasium on the third floor, it was in operation until 1958, when the

building was deemed to be structurally unsound and dismantled. The New Baltimore municipal offices and fire department now occupy that site.

James S.P. Hatheway was a shrewd businessman and, by all accounts, not very well liked around town—upon his demise, it was written that no one seemed to mourn his death.

What made James such a bitter man is anybody's guess. Some attribute it to the sudden death of his daughter Mabel and the fact that he suffered from the same debilitating disease as his father. After having rheumatoid arthritis for several years, James would use a cane to help steady himself when he walked. Later in life, he was confined to a wheelchair.

The local story is that James died in 1887 from injuries suffered when his wheelchair accidentally sent him tumbling down the stairs. His death record states that he died due to an accident. Some speculate that his fall wasn't accidental, but no evidence supports that. There isn't any evidence that disproves it, either.

But the member of the Hatheway family most shrouded in mystery is James's daughter Mabel Hatheway.

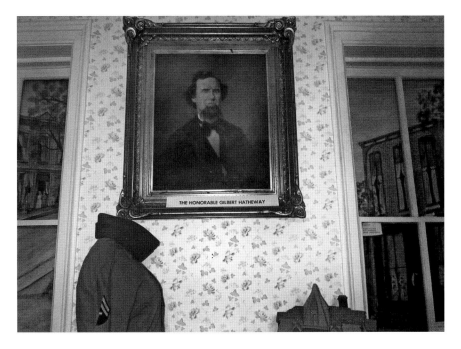

Portrait of the Honorable Gilbert Hatheway. It is the only known picture of this great man. *Author's collection.*

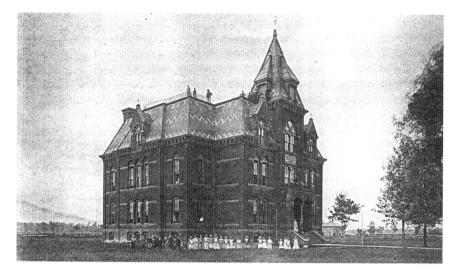

The Hatheway Institute was built with the money that Gilbert Hatheway left to the city in his will. *New Baltimore Historical Society Collection.*

Mabel grew up a member of high society in New Baltimore before spending a year at Vassar. She returned home and, by all accounts, spent a lot of time in Paw Paw, Michigan, with friends. It was there that she met Oren Dunham, a schoolteacher.

Mabel and Oren were married on December 26, 1880. Mabel Hatheway was twenty-years old. Less than three months later, she was dead. Until recently, the cause of her death was unknown, but it's been the subject of local folklore and speculation for well over one hundred years, and the debate rages even today.

Many people believed that Mabel died from a fall down the stairs in the Hatheway mansion. Some even went so far as to say that she was either pushed down the stairs or thrown over the bannister on the third floor and landed on the first floor, dying instantly.

The truth is not so dramatic. But, in true Hatheway fashion, it leaves more questions than answers. According to old newspaper articles, Mabel died on Thursday, March 24, 1881, after an illness that lasted about a week. However, no death certificate has been located as of this writing. The day after her death, her husband, Oren, accompanied her body by train to Detroit. An old family friend of Mabel's parents, who happened to be an undertaker, met the body. The funeral was held at St. Paul's Episcopal Church that Sunday.

After the service, the body was housed temporarily at Elmwood Cemetery in Detroit before being permanently interred at Oakwood Cemetery in New Baltimore. It's believed that the dirt roads leading to Oakwood Cemetery may have been too muddy because of the spring thaw to allow taking Mabel's body to the cemetery. Another possibility is that the ground was too frozen to dig her grave; Elmwood Cemetery could house her casket in its mausoleum on a temporary basis.

Whatever the reason, when Mabel was permanently laid to rest, her father commissioned a special memorial that is described on the receipt as a "crib" to be placed on her grave. Made of marble, the monument resembles a bed with a headboard, sideboards and small footboard. Planted within the crib, or bed, is lily of the valley that continues to bloom every year to this day.

Local folklore suggests that James chose lily of the valley because it is a poisonous plant—James was trying to send a message that his precious little girl was poisoned. There is nothing to substantiate this story, but it's an interesting thought.

You see, Mabel was an heiress. When her grandfather Gilbert Hatheway died, he left a substantial amount of money to her in his will. Because Mabel

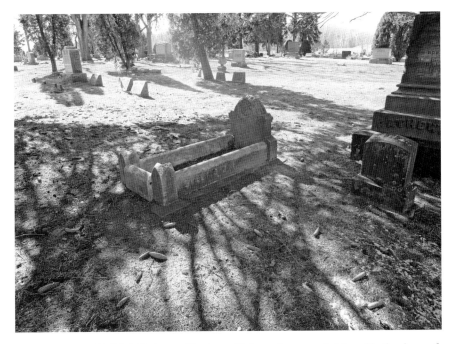

The gravestone of Mabel Hatheway Dunham. To have the stones fashioned in the shape of the bed cost $750 in 1881. *Author's collection.*

was only nine at the time of her grandfather's death, her father managed the money until she reached adulthood.

Some people, even today, speculate that Mabel's husband, Oren, would have a lot to gain by his wife's death. While this is true, there is no evidence that even remotely points in that direction. By all accounts, Oren was an upstanding citizen and extremely well respected in the community. In other words, he was not the type of man who would murder his wife.

Now that we've talked about the family, let's move to the house!

The original house stood three stories tall and was approximately three thousand square feet. A large cupola rested gently on the roof. Large bay windows thrust themselves from the front of the house, and nestled in between them was a gracefully rounded porch.

When James's wife, Evaline, sold the house sometime after his death, the new owner, Abby K. Tillotson, added a large three-story addition off the back of the house and turned it into a successful bed-and-breakfast called the Firs.

Rumors have swirled around the area for years that the house was once an insane asylum. While the home was purchased by a doctor with that intent,

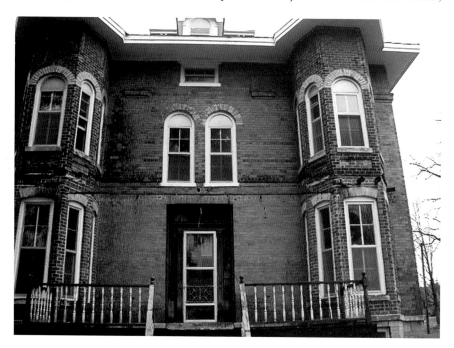

Front view of the Hatheway house. Some people swear they see ghostly faces in some of the windows. *Author's collection.*

the doctor was unable to get licensed by the state. Her clinic never opened. Soon after that, the doctor sold the home.

In fact, the home changed hands many times over the years until it was finally purchased and torn down. The huge plot of land it sat on was subdivided, and new homes were built.

The home is gone, but it is most certainly not forgotten. It was considered one of the most haunted houses in the area, if not in the state of Michigan itself.

Many of the occupants reported hearing footsteps on the stairs, but they said it sounded like a loud thumping, as if someone was walking with a cane. Other people have said that when they were in the house as little girls, someone would playfully tug at their ponytails or swish their hair. Others have said that they would see white mist appear in the outline of a person and "float" across a room and up and down stairs and then dissipate as quickly as it appeared.

This white mist seemed to be prevalent on the stairs that led to the cupola and in the cupola itself. If this is the case, this activity could be attributed to James Hatheway. It's widely believed that James spent a lot of time in the cupola because he could see the downtown area from there, and he would watch his ships coming into or leaving port from the Hatheway dock.

At various times, workmen and the homeowners would be working on the house and would report tools missing only to reappear somewhere else in the house a day or two later. Construction supplies would be moved during the night, and power tools would turn on and off without being touched by human hands.

Some have reported feeling as if all their energy was being drained from their bodies after being in the house for only an abbreviated time.

This feeling was experienced mostly in the basement of the home but felt stronger in one specific room of the basement. The basement stairs were so worn that when you walked down them, you had to walk in the footsteps of the many people who came before or you would not be able to keep your balance.

Very few dim lightbulbs hung from the ceiling, making an already eerie place more mysterious. The basement itself was divided into many different rooms. At the bottom of the stairs was a large room to the right and a long, large room to the left. A hallway led down the center of this basement, and there were dividing walls in this area that led to several smaller rooms. Continuing down the hall, you'd end up in a large room at the back of the basement.

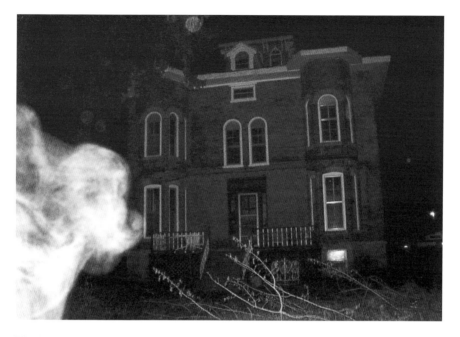

The Hatheway house at night. The mist was not present to the human eye when this picture was taken. Is that something in the basement window? *Author's collection.*

However, it was the room to the left at the bottom of the stairs that most people were interested in. This room was the only room in the basement with a dirt floor. It housed the furnace and hot-water heater.

At the far end of this room was a large hole in the wall that led to an area under the front porch. How the hole got there and who put it there is a mystery that died with the house, but it's this room that seemed to creep people out the most.

I've personally spoken to several people who, upon walking out of that room, have stated that they feel as if a body was buried or hidden somewhere in that space. It needs to be said that the research this author has seen to date hasn't turned up any likely possibilities to support these feelings or statements; however, it doesn't make them any less valid.

One of the last owners of the property reported that during one winter, the furnace went out. He called a friend who knew something about heating systems, and together they trudged down the basement stairs and went in the room to the left to have a look at the furnace.

Just as they were taking the furnace apart, a thunderous male voice came out of nowhere and yelled for them to "Get out!" Knowing they were the

only two people in the home, the men, extremely scared, raced up the stairs and out of the house.

They returned a few days later and once again headed to the basement to fix the heating system. Again, the same voice ordered them out of the house. At this point, the men gave up for a week or two before they were finally able to repair the furnace without incident. However, they were both so shaken up by the experience that the owner of the home put it up for sale.

There are some who believe there was something far more evil and sinister in the basement and house besides ordinary ghosts of the living who once occupied the home. There are some who believe a demon occupied the room with the dirt floor in the basement and that the entrance to its nest was the hole in the wall that led under the porch. Many people who've been in the home have reported the energy in the basement to be heavy, oppressive and/or depressing. According to research, these feelings are quite common where a demon is believed to be present.

There were quiet whispers around town and on the Internet about people smelling sulfur (a phenomenon that is said to occur when demons are present) at times in the house and about some of the occupants having meat rot in the refrigerator even though it was purchased that day or the day before. There were also reports of people being scratched and an unseen force trying to push them down the flight of stairs leading to the third floor.

The police were called to the house numerous times when it was empty, because kids or other groups were breaking into the house. In some cases, these people would light candles and chant in an apparent attempt to contact the spirits, conjure a demonic entity or make contact with the demon that had allegedly taken up residence in the basement.

Here's the thing about the basement: it's still there! When the house was torn down, the basement wasn't removed. It was just filled in. In the paranormal world, this could mean that all the ghosts, phantoms and specters that once walked the halls of the house and resided in the basement are still there. The energy of the house still occupies that land and will continue to do so for the foreseeable future.

While I conducted research for this book, one person commented that it "appeared to them as if the house had a soul, that it was alive, and would take extraordinary measures to protect itself and survive in some way." After spending years not only being in the home but also investigating the house and the Hatheway family, I'd have to say I agree with that assessment.

As of this writing, there are reports of strange lights shooting out of the ground from where the basement still exists—watching…waiting.

5

OAKWOOD CEMETERY

As a rule, cemeteries are not haunted. Ghosts and spirits generally return to places they loved when they were alive or return to where their still-living loved ones reside. Of course, like everything else, there are exceptions to this rule, and Oakwood Cemetery is one of those exceptions.

The cemetery sits on the outskirts of New Baltimore on land donated by the Rose family, who were extremely prominent citizens in the area. However, early maps show that at one time, a Native American village may have occupied a lot of the land in and around the cemetery. It's also just down the street from where the Hatheway house once stood.

It's a rather large cemetery surrounded by a wrought-iron fence. Hundreds of tall oak trees grace the landscape. A small, white building with a wraparound porch stands just inside the entrance, housing a small office, storage for the equipment needed by the cemetery to maintain the grounds and a wooden bench that is attached to the building on both sides (see front cover of this book). This building adds a certain charm to the overall quaintness of the cemetery. The oldest graves date to the early 1800s and contain the remains of some of the most prominent people alive during New Baltimore's early days. The cemetery is still accepting new interments, as well. Although many of the old tombstones need to be repaired and restored, the cemetery maintains a peaceful and graceful presence in its residential surroundings. Many residents in the area walk through the cemetery for exercise, as it's off the main road and safer for pedestrian traffic.

One of the older sections of Oakwood Cemetery. It's an extremely serene place to rest in peace. *Author's collection.*

Early records indicate that at one time a potter's field was present in the cemetery, situated toward the rear of the cemetery on the east side. For those who don't know, a potter's field is a place in a cemetery where unknown people, indigents and criminals were buried. Such burials were, in most cases, paid for with city funds.

However, sometime in the 1930s, the cemetery sold grave plots over potter's field, and it, and the people buried there, disappeared into history. All that remains is an old book with laminated pages that tell of who was once buried there. Those records are sketchy at best. In many cases, no names are entered, just assumed nationalities and a note that they were interred in potter's field.

At that time in history, New Baltimore was a busy shipping port. It wouldn't be uncommon for people whose names were not known to be in the town and, in some cases, die there.

There are times, especially in the early evening, just before dusk, when you can walk through the cemetery and hear someone following you. People have reported hearing footsteps and seeing footprints being made in the

snow in the wintertime. Others have reported footfalls crunching the leaves behind them or, in some cases, alongside them in the fall. In some of these cases, when the person stops walking, the footsteps being made by someone unseen stop, as well, and then resume if that person starts walking again. Although some reports of this phenomenon have been made regarding the oldest parts of the cemetery, most of the reports have shown that, generally, this type of activity takes place west of the white building, close to the graves of the Hatheway family.

Speaking of the Hatheway family, a local psychic who wishes to remain anonymous but whom we shall call Lisa visited the cemetery one day and reported seeing the spirit of Mabel standing by her grave. Lisa got out of her car and slowly approached the spirit. Lisa said that Mabel looked at her, pointed to a vacant patch of land next to her mother's and father's graves and said, "Something's missing here." Mabel repeated those words several times before fading into nothingness.

Curious about the encounter, Lisa began to do some research. She soon discovered that Gilbert Hatheway and his wife, Abigail, were once buried

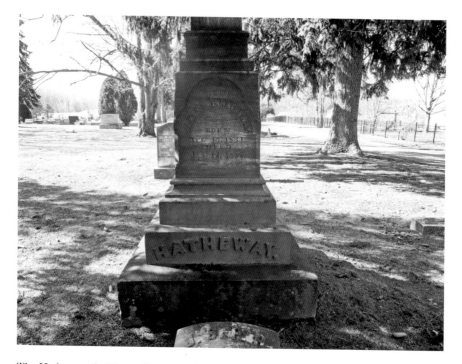

The Hatheway obelisk stands to your right as you drive through the front gate. Even in death, the Hatheways have a prominent position. *Author's collection.*

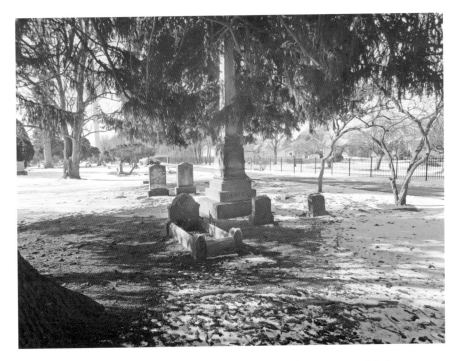

The graves of Mabel, James and his wife, Evaline. The blank space to the right is where Gilbert Hatheway and his wife, Abigail, were once buried. *Author's collection.*

exactly where Mabel was pointing. They had both died while Mabel was still alive. What happened to them? Lisa discovered through further research that in the late 1800s or very early 1900s, Gilbert Hatheway's daughter Isabella, who resided in Adrian, Michigan, had petitioned the court to have the bodies of her parents exhumed and moved to a cemetery in Adrian. The reason Isabella wanted the graves of her parents disturbed and moved so many miles away has been lost to history, but the order was granted. Isabella was free to move forward with her plan.

Lisa found out that, according to an oral history given by the assistant grave digger at that time, Bill Baker, the caskets were dug up and, when pulled out of the ground, fell open to reveal the bodies. Gilbert Hatheway's body was perfectly preserved, while that of his wife, Abigail, was reduced to bones. This told Lisa that, while Gilbert had been embalmed, Abigail hadn't. The caskets were moved to a livery stable, encased and soldered in tin and then transported to Adrian for reburial in the city cemetery.

It is worth noting that as the town of Adrian expanded, the city cemetery was shut down. All the bodies and tombstones were moved to another

location just outside of the city. In a twist of irony, the bodies were reburied in Oakwood Cemetery of Adrian, Michigan.

Armed with this information, Lisa returned to the cemetery and, over Mabel's grave, gently informed her of what had happened to her grandparents. You might think this would allow Mabel to rest in peace, but it hasn't. Not that Mabel's spirit doesn't want to—it's the living who won't let her drift into death's eternal slumber.

Quite a few people still visit Mabel's grave to this day, some to leave her flowers, others with different motives in mind.

In the not too distant past, there were reports of sea salt being poured around Mabel's grave on at least two occasions. In some circles, it's believed that a negative spirit or entity cannot cross a line of sea salt. Putting sea salt around someone's grave would thus prevent them from leaving their grave and roaming among the world of the living—in other words, haunting someone.

Whether this was the act of kids or of someone who believed that Mabel was haunting them or their house is unknown. If the latter, whoever performed such a heinous act must have been terrified and/or desperate to stop whatever paranormal activity was occurring around them or in their home. The sad thing is that everything known about Mabel indicates that, in her short life, she was much loved. There is nothing to indicate that she had an evil bone in her body. So, pouring salt around her grave would have no effect, because she is not an evil or negative spirit.

Many other areas of the cemetery have paranormal activity, and one of the creepiest reports is that of the shadow people. Shadow people are entities that appear just as their name implies—as dark shadows.

There is some controversy in the paranormal world as to whether shadow people are a form of demon or an entity of unknown origin. There have been many reports of shadow people having red eyes. The problem with trying to identify a shadow person is that there are other entities that can appear as dark shadows.

One of the main characteristics of shadow people is that they generally are watchers, meaning they just observe. They are not known to want to interact with the living and, in most cases, will quickly scurry away from the living once they've been noticed. Many people believe shadow people are the things you catch just out of the corner of your eye but, when you turn to look, there's nothing there.

In Oakwood Cemetery, however, the shadow people will watch and observe from a relatively safe distance. One of the people who related

their encounter said that they were sitting on the bench at the white building, facing west. They said they were lost in thought for a period of time, and when they again became aware of their surroundings, they noticed shadow people observing them from behind trees and some of the taller, bigger tombstones.

At first glance, the person thought they were just seeing shadows from the trees and grave markers. Taking a closer look, they realized that wasn't the case at all. The dark shadows had rough human forms and didn't move like the other shadows did when the wind blew through the trees. When the person got up and walked toward one of the shadow people, it simply vanished.

Several other people have reported similar encounters with the shadow people while in the cemetery. The main thing that all the shadow people reports have in common is that the witnesses were not paying attention to what was around them for one reason or another. They also reported that they were caught unawares and off guard by the sudden appearance of the shadow people but didn't feel threatened by them.

Other reports of paranormal activity in the cemetery include hearing children giggling and playing when there are no children in sight and experiencing the feeling of being watched. In some cases, full-body apparitions have been reported and caught on film.

A full-body apparition showed up at one of the many cemetery tours that are given each year. I guess he didn't want to be left out of the festivities. *Kimberly Paulson-Avolio.*

The gates of Oakwood Cemetery, where the Guardian of the Gate hangs out. No, those aren't orbs, they're bugs. *Linda Sparkman.*

Some people have even reported seeing Native American spirits just beyond the fence at the rear of the cemetery or just inside the fence at the same location. Research has shown that there may have been a Native American settlement at the area behind the cemetery at one time, but the exact location can't be ascertained.

One of the most interesting ghosts in Oakwood Cemetery has been aptly named the "Guardian of the Gate." This spirit hangs around the front gate of the cemetery, and there is much speculation as to who this spirit was when he was alive.

One theory is that the spirit was once a caretaker at the cemetery and is still tending to its duties as it did when he was alive. Another theory is that the spirit is of someone who is buried in the cemetery but enjoys watching the comings and goings of the living and, while he's at it, keeps an eye on who comes in and out of the cemetery. Either of these theories may be correct.

While most of the people buried in Oakwood Cemetery seem to be resting in peace, there also appear to be some restless souls that prefer to continue to mingle with the world of the living.

6

LOST CITIES AND SPIRITS

Could a lost town and an old Catholic mission that were swallowed by Lake St. Clair be responsible for some of the paranormal activity in the area?

It's an interesting premise, and the theory could, pardon the pun, hold more water than some people think. In the paranormal world, it wouldn't be out of the ordinary for a ghost or spirit to want to let the living know where they were, to not want to be forgotten and/or to want to somehow make a connection with the world of the living.

While many towns in the Anchor Bay area have disappeared over time, some paranormal researchers are taking a closer look at the lost city of Belvidere and the St. Felicity Mission.

The reason these two areas are gaining so much attention is because of an increased amount of paranormal activity along the shoreline near where these two places once stood.

To better understand why this is happening, it's important to take a closer look at the history of these two lost places.

In 1835, the town of Belvidere was a dream of James Conger, who envisioned a magnificent city at the mouth of the Clinton River. He felt it was the perfect location because of the abundance of trees, including oak, maple, black walnut and whitewood, and because the richness of the soil would allow for farming.

When pitching his idea for Belvidere to potential investors, Conger pointed out that the Michigan legislature had just chartered a railroad with banking privileges to construct a railway from Saginaw to the Clinton River

Somewhere under the blue waters of this part of Lake St. Clair lies St. Felicity Mission Cemetery. *Author's collection.*

and that another railway was being considered that would join Belvidere with towns like Pontiac and Utica. Unfortunately, during the Panic of 1837, the railroad projects were abandoned

Conger also counted on the construction of a canal on the Clinton River that would stretch from Belvidere to Kalamazoo. This canal would tie the eastern part of the state to the western part, allowing ships of any size with a flat bottom to cut through the middle of the state instead of having to travel around the Great Lakes.

After enough investors showed interest, the Belvidere Company was formed, including shareholders James Conger, Thomas L. Peck, Richard Hussey, James Tallman, Abram Smith, Elizabeth Smith, Timothy Ingraham, Thomas Balten and Nelson Oviatt. James Conger's brother David was also a shareholder, but he soon sold his shares to his brother and the other investors.

Later in 1835, James and David Conger purchased the land at the mouth of the Clinton River from Alex Peltier, Joseph Robertjean and Ignace Moross. James Conger's investors must have been solidly behind him, as they all moved to Belvidere.

Then, in 1936, one hundred lots were sold at auction under the terms that the purchaser could pay 20 percent in cash and the balance was to be paid in four installments of 20 percent each, after which title would be issued to

the landholder. A 10 percent discount was offered to those purchasers able to pay for the property outright. Sad to say, sales were not quick to happen, and James Conger bought seven lots for himself, Blackwell bought one lot and a few of the other investors purchased lots.

Construction began shortly thereafter, and it wasn't long before a sawmill, warehouse, docks, hotels, stores, tavern and post office were constructed. In addition, carp fisheries sprang up seemingly overnight.

Things were going pretty much according to plan until a series of events doomed the town of Belvidere to fail.

The Bank of Lake St. Clair, which was vital to Belvidere, opened in March 1838 with James Conger as president. Considered a wildcat bank, common to that era, it was capitalized with only $50,000. The bank closed later in 1838. It had printed banknotes, but none of them were ever signed. One source indicates that the bills were circulated and used as money, mostly to fool ignorant and unsuspecting people.

In 1836, huge rains came to the region, and twice the Clinton River breached its banks, sending the residents of Belvidere to higher ground.

Reverend Supply Chase wrote, "Orchards of 59 years' growth were destroyed, houses flooded." Reverend Chase also reported that transportation from Belvidere to Detroit was interrupted and that starvation threatened farmers as the rains washed out their crops. The farmers were forced to eat leeks and swamp reeds like their livestock. The Bank of Lake St. Clair was completely flooded.

In 1838, the waters of Lake St. Clair reached historical highs; the lake had risen six feet. The cellars of the buildings were filled with water, and all the structures became unusable. There were also periods of sickness, pestilence and fire.

In 1827, authorization had been given for the canal, and $5 million had been appropriated for the project. The original plans called for the canal to start at Mount Clemens, not Belvidere, but James Conger thought he could make a good case for the town of Belvidere to be the starting point.

This was a gross miscalculation. Mount Clemens had more political clout than the fledgling town of Belvidere and easily won that fight. As a result, the first locks for the grand canal were built inland and away from Belvidere and were poured and positioned in such a way that it was extremely unfavorable to Belvidere.

As it turns out, it didn't matter—the grand canal was never completed due to the growth of the railroads, the bad economy and a lack of funds. The project was abandoned in 1843.

Despite all the setbacks, Conger remained in Belvidere and moved his family to the second floor of the hotel. James Conger's wife died, and she was buried in Belvidere. As the waters rose, though, she was moved to higher ground. Soon, even Conger came to the realization that his dream had died; he left his beloved Belvidere and moved to St. Clair County, where he later died. His last wish was granted, and he was buried at Belvidere. But when the waters of Lake St. Clair once again began to rise, his body was moved to Greenlawn Cemetery in Columbus, Ohio.

In Harrison Township, Michigan, there is a short street on the shores of Lake St. Clair named Conger Bay Drive, in honor of the man who once dreamed of a magnificent city on the bay.

The St. Felicity Mission has slightly humbler beginnings than the grandiose dreams that built Belvidere. The St. Felicity Mission was one of three missions established by Gabriel Richard in 1824. The land was originally purchased from a farmer by a French missionary, Father Pierre Dejean. By 1826, the church, forty feet long and thirty feet wide, was being erected, and Father Francis Vincent Badin was assigned to the parish.

In 1829, during the Feast of Corpus Christi, Bishop Fenwick dedicated the church to St. Felicity and gave permission for a cemetery to be erected on the site. It was decided that the cemetery would occupy two acres of the property.

Between 1836 and 1838, the church periodically flooded. However, as the floodwaters receded, the church was still being used, and people were still being buried in the cemetery. In 1855, Lake St. Clair rose and, once again, claimed the church and cemetery. Neither ever recovered from the devastating flood.

Local folklore suggests that the farmer whose land was purchased for the mission was buried under the altar of the church. It's unclear whether his body was relocated before the church was lost to the water; most people are certain that none of the bodies in the cemetery were exhumed and moved to higher ground.

Many decades passed, and the exact location of the church was lost to history. However, in November 1995, years of research by one priest came to an end when divers from the Dossin Great Lakes Museum located the cemetery in about ten feet of water and two thousand feet offshore. The church, however, has yet to be located. It may never be found, due to the fact that in its time, timber was generally recovered and reused for other buildings. The priest from the church that was built to replace the St. Felicity Mission had spent well over eight years researching the mission.

It was reported to me that while the priest was researching the mission, someone broke into his locker at the parish and was successful in destroying most of his research. The motive behind this heinous act is not clear and, according to my source, "defies all logic and decency." While the motive for destroying years of research may not be known, one thing is crystal clear: there are many reports of paranormal activity on the shore near where the mission once stood.

Reports by homeowners and business owners around both Belvidere and St. Felicity Mission include full-body apparitions appearing in period clothing. One account involved a homeowner who saw a very stern-looking woman in Victorian dress walk through her home one night as she and her husband were watching television. According to the report, there is a hallway from the back of the house to the great room at the front of the home. The woman and her husband were watching a show when, from the hallway, a woman walked through the great room and out the front window of the house. The husband and wife were interviewed separately, and both came up with the same detailed description of this older woman.

They said she was extremely translucent and wore a long dress common in the Victorian era. They reported that the woman did not acknowledge their presence in the room. The wife said she got the impression that the ghost was on its way to somewhere important and seemed to be in a rush.

It's entirely possible that this event was caused by residual energy and not a spirit. Residual energy is quite common. It involves an event replaying itself over and over, like a video on continuous loop. There isn't a spirit present, just the energy of the person who might have walked that way frequently when they were alive. However, it's just as possible that it was a spirit passing through, heading home to a long-lost town. While researching this book, I heard several reports of the same type of activity in other homes along the shorelines where these two towns once stood.

One story was particularly creepy. A woman named Julie, whose husband traveled a lot for business, said that on the nights he was gone, she would sometimes suddenly wake up in the middle of the night. On each of these occasions, she would look around the bedroom, trying to find what caused her to wake up.

She went on to say that on many of these nights she would see an old woman sitting in the rocking chair in her bedroom, gently rocking back and forth. At first, Julie would scream at the sight, and the woman would vanish into thin air. After the third or fourth time, Julie would try to speak to the woman. Most of the time, the woman did not acknowledge Julie's presence;

she would continue to gently rock. However, on a couple of occasions, the woman looked over at Julie and smiled before disappearing.

Because the old woman showed up only on nights when Julie's husband was out of town, Julie began to wonder if the woman in the rocking chair was watching over her and protecting her in some way while her husband was away.

This explanation seems plausible, but it still doesn't answer the question of who this woman is. Julie spent many an hour combing through old family photo albums trying to identify her, but to no avail. Could this old woman be someone from one of the towns that disappeared due to flooding? That, too, is possible, as Julie's home sits at the water's edge of the lost city of Belvidere.

While the lost cities may be one explanation for the rash of paranormal activity in many areas along Anchor Bay, another one may explain some of the activity in one or more areas of the region.

There is at least one subdivision—and there are probably others—built on top of the fill dirt that accumulated during the construction of the expressway connecting Port Huron and Detroit. The freeway is an interstate, but for purposes of this book, the area we shall be concerned with is the stretch of the freeway from north of Detroit to the New Haven area.

Undoubtedly, homes, roads, old railroad tracks and other structures— perhaps even a few old family cemeteries—were destroyed to make room for the freeway. Much of the excess fill dirt was moved to various locations across the county. In time, subdivisions, businesses and other infrastructure were built on top of it. Such a disturbance of the land could, in some cases, be enough of a catalyst for paranormal activity to occur, and this could explain the frequency of supernatural events in these areas.

For example, a neighbor down the street confided in me about some interesting paranormal activity in her home. She is allowing me to tell her story, as long as I substitute her name with an alias.

Betty lives in a rather upscale neighborhood near Anchor Bay. While the house itself is rather new, Betty's decor style is early American, and she owns some amazing antiques. Her taste is excellent, and the home is decorated so beautifully that it should be in a magazine.

On a rather large, circular, marble-topped table in her living room is a large, hand-carved wooden bowl. Inside the bowl are balls made of various materials, such as bamboo, twigs, wicker and other natural fibers.

Betty has a cat that is extremely fond of playing with these balls from time to time, and it's not unusual to find them scattered around the room and on

the furniture. What is unusual is that, sometimes, one or more of the balls will be tossed out of the bowl, generally in the direction of the cat.

This phenomenon will happen as people read while sitting on the couch in the room or in one of the chairs by the window. Betty, her daughter (when she's home from college), her husband and a few guests have witnessed this event on more than one occasion. Betty believes that whatever spirit is in their home is fond of cats, and the strange activity doesn't bother her. Some of the paranormal activity going on in the home Betty finds amusing; other activity, not so much.

Sometimes, when Betty is walking down the hardwood staircase in their home, a dime, a penny or a nickel will appear out of nowhere and fall in front of her, bouncing off the steps. Sometimes, more than one coin will fall at a time. Some people might say that this is just spare change falling out of the pocket of her pants, and in some cases that may be true. However, the coins start to fall from above her head, passing before her eyes, and in most cases, Betty is the only person home at the time this occurs.

Betty has picked up and examined the coins and has found that they are not particularly old. Her theory is that the ghost is taking some of the spare change out of a jar she keeps on the kitchen counter and is either trying to scare her or, as Betty prefers to believe, is just having a little fun at her expense.

Sometimes, Betty feels as if she's not alone in the house. In other words, she senses a presence, but she has never felt threatened by the ghost or ghosts that share the family home.

Betty wonders if the spirits are there because the home is built on fill dirt from the freeway or because of the proximity of the home to the lost cities. She also ponders whether they are attached to one or more of the many antiques that grace the rooms of her home.

While she may never know the answer to that question, Betty and her family continue to live in harmony with the spirit and/or spirits that choose to stay connected to the living in some manner.

There have also been reports of people driving along the lake at night seeing strange people near the shoreline, but when they look back, the people disappear before their eyes. Could these phantoms be walking toward the lost towns, as they did when they were alive?

Other residents have reported having their music boxes play on their own at times and doors opening and closing under their own power. One particularly disturbing story centers on a spirit that whispers into a woman's ear at night while she's sleeping, but the woman can't understand what the spirit is trying to tell her.

7

Shipwrecks, Ghost Ships and Other Great Lakes Mysteries

For some people, the term *ghost ship* conjures up images of large, phantom vessels sailing the high seas. While there are such ships on the world's oceans, the Great Lakes has so many ghost ships that these phantom vessels have been dubbed the "Ghost Fleet." Some of the ships considered to be in the ghost fleet include the *Griffon*, *Bannockburn*, *W.H. Gilcher* and *Western Reserve*.

In many cases, the wrecks of what are now ghost ships involved the loss of life. Could this be the reason for the very existence of ghost ships? Could it be that the spectral crews aren't ready to abandon ship and are still sailing the Great Lakes and other waters throughout the world? While we may never know the answer to these burning questions, in the world of the paranormal, it would be considered a plausible explanation for some of the sightings, especially when so many accounts of ghost ships involve the spirits of long-dead crewmen.

The Anchor Bay area and Lake St. Clair are not considered to be on the Great Lakes, but they have their share of sunken vessels and perhaps a ghost ship or two.

H. Houghten

Take, for example, the *H. Houghten*, sometimes erroneously spelled "Houghton." This vessel was built in 1889 in Bay City, Michigan. It had a propeller and was constructed completely of wood. It was, during its lifetime, a bulk freighter and sand sucker.

A sand sucker, for those who don't know, is a vessel equipped with tiny suction dredges that mine the sand from the bottom of lakes, mostly in the shallows, and give new life to boats that otherwise may have been scrapped.

The *H. Houghten* burned to the waterline on the morning of November 20, 1926. At the time of its demise, it was near Harper's Point, seven miles south of Algonac. The interesting thing about this vessel is that it had previously sunk in a collision at the south end of Lake St. Clair on September 9, 1902. The ship had been carrying a cargo of stone. Two lives were lost. In 1920, it was turned into a sand sucker. It remained in operation until the fire of unknown origin.

MAINE

The vessel *Maine* seemed to be cursed, and it wouldn't be a surprise if this ship still sails as a ghost ship on Lake St. Clair. The *Maine*, built in 1862 by Stevens and Presley out of Cleveland, was equipped with a propeller, was constructed of wood and was used mainly as a bulk freighter.

In 1871, a boiler explosion occurred onboard; six lives were lost. It sank in the Welland Canal in 1872 and was raised and rebuilt. The ship also had major fires in 1880, 1892 and 1906. It once again sank in Lake Superior in 1906. However, it wasn't until the ship was destroyed by fire on July 17, 1911, burning at its owner's docks, that it was deemed a total loss.

FRANK MOFFAT

Another seemingly doomed vessel was the steam tug *Frank Moffat*. It was a completely wooden vessel and was equipped with a propeller. It was built in 1869 by Fitzgerald & Leighton out of Port Huron and was owned by the Moffat Tug Line, also located in Port Huron.

On the St. Clair River, the ship was wrecked in collisions in 1873 and 1883. It sank on November 1, 1885, when the boiler exploded. The loss of life was devastating, killing five of the twelve people aboard. The vessel sank while performing a "round to" maneuver. It was towing five barges and, after the explosion, was a total loss.

N. MILLS

The *N. Mills*, also known as the *Nelson Mills*, was built by P. Lester in Vicksburg (now known as Marysville) in 1870. It was completely constructed of wood and was built as a barge meant to carry bulk freight. It was equipped with an engine and a propeller in 1871. As with many other ships, it had a run-in with disaster more than once.

In 1892, it breached and suffered heavy damage in the Straights. It also underwent major repairs in 1880, but there isn't a record to state why such repairs were necessary at that time.

On September 6, 1906, on the St. Clair River off McGregor Point, it collided with the steel steamer *Milwaukee* and sank. Two lives were lost. The crew of the *Milwaukee* and other nearby boats rescued the survivors. Later, the *N. Mills* was blown up to clear the channel for other vessels.

BOTHNIA

The *Bothnia* was built in 1895 by D. Calvin in Garden Island, Ontario, and was originally named *Jack*. It was renamed in 1896. It was built partly of tamarack and was a bulk freighter.

In 1895, after a collision that sank the steamer *Norman*, an appraiser remarked that the construction of the *Bothnia* was some of the strangest he'd ever seen.

On June 26, 1912, it collided with the steel steamer SS *Curry* and sank near the Star Island House on the St. Clair Flats. One life was lost. The vessel was later removed.

C.M. FARRAR

The *C.M. Farrar* was built as a steam tug by G. Notter of Buffalo, New York. In June 1873, it suffered a boiler explosion and a fire that killed three crew members and almost destroyed the vessel. Then in September 1876, it hit a snag and sank in shallow water. It remained there until a few years later, when it was recovered and placed in service until 1889.

The preceding list is not all-inclusive but just a highlight of the most intriguing wrecks from a paranormal perspective.

It was reported to me by a fisherman who wishes to remain anonymous that, once, he was out fishing very early in the morning on one of the channels near Anchor Bay. The lake was lying flat, as it generally does that early in the morning, and a light mist or fog was present, as is typical.

He'd just completed his first cast of the day when something in the distance caught his eye. Out of the early-morning fog, he saw what he thought was a sailboat. However, taking a closer look, he realized it was an old three-masted schooner. As he watched the ship glide easily over the water, out of the fog and into the early-morning sun, it simply vanished into nothingness.

Although the fisherman was a little befuddled by his experience, he kept it to himself for many years, and although he hasn't seen the vessel since that day, he keeps an eye on the horizon every time he ventures out into the lake in the early morning.

Artist rendering of a shipwreck on stormy seas. *Comfreak*.

So, the next time you venture out onto Lake St. Clair when the haze and mist are still lingering on the lake, pay attention. You, too, may be one of the lucky ones who sees a ghostly ship appear on the horizon and vanish before your very eyes.

THE BLACK DOG OF LAKE ERIE

The "Gales of November" are often accused of being the culprit in the mysterious disappearances of ships on the Great Lakes. And make no mistake, the gales have sunk many a ship over the years.

However, there may be another reason, paranormal in nature, that explains why some ships sink into the murky depths of the Great Lakes and Lake St. Clair: the Black Dog, better known as the Black Dog of Lake Erie.

Unlike one of the hellhounds that have been known to cause chaos in various locations around the world, the Black Dog is the ghost of a dog that used to be a ship mascot. It's believed that when the dog appears on a ship, it's a bad omen for the ship and crew alike.

The legend of the Black Dog finds its roots in the Welland Canal near Niagara Falls. It's said that a ship was traveling through the canal when its mascot, a black dog, fell or was pushed off the ship. The dog was an extremely large Newfoundland, a species known for its abilities in the water.

No one is sure what exactly happened, but there are tales that for sport the crew members would tie the dog to a long rope and make it swim alongside the ship. What really matters is that the dog, on this particular occasion, was crushed to death in the gate of the canal lock.

It reportedly took hours for them to dislodge the dog's body from the gate of the canal, only to have their nights haunted by the baying of the dead dog that was treated so cruelly and that they didn't save.

Since that time, the ghostly dog appears on ships that are going to run into trouble; the stories have implied that the dog is cursing the ships and causing them to sink. Others believe just the opposite, that the dog is trying to warn people that the ship is going to run into danger.

One description of the Black Dog says that he has "eyes like coals of fire"; this has led people to believe the dog might not have the best interest of the ship in mind when he appears. According to stories, the Black Dog will either appear onboard the doomed ship or climb aboard from the water,

Artist rendering of the Black Dog. *Bykst.*

race across the deck and then jump off the other side. Soon after that, the ship will run into trouble.

It's widely believed that the Black Dog caused the sinking of the ship *Mary Jane* in Lake Erie on November 19, 1881. The *Mary Jane,* a schooner built in 1862, was carrying a load of telephone poles when a storm crashed it into the shore near Port Rowan, Ontario, snapping the ship into pieces and causing the death of all nine crew members. You could say that the storm caused the *Mary Jane* to wreck, and you would be right, except for the simple fact that the workers on the wharves at Port Colbourne, Ontario, near where the ship crashed, saw the Black Dog leap from the schooner and vanish as soon as it set foot on the dock.

Despite its nickname, the Black Dog of Lake Erie has been blamed for shipwrecks in some of the other Great Lakes. Perhaps the vengeful Newfoundland has just left fewer witnesses in Lake Erie than at some of the other wrecks it's credited with causing.

One of the victims of the Black Dog was the ship *Issac G. Jenkins,* which sank on November 30, 1875, in Lake Ontario, quite possibly near Oswego, New York. Lake Ontario is situated right next to Lake Erie.

The story goes that the helmsman woke up the captain one night and told him he'd seen a large Newfoundland climb aboard the ship, run across the

deck and leap overboard into the darkness. The captain, instead of listening to the helmsman, angrily accused the man of drinking on the job. The helmsman either quit or was thrown off the ship at Port Colbourne. The story goes that the helmsman followed the ship as it traveled along the same canal that was the site of the origin of the Black Dog legend. He gave constant warnings to the crew when they stopped along the way, but the warnings fell on deaf ears.

The *Issac G. Jenkins* simply vanished en route to Oswego. While some of the wreckage floated ashore, the crew members were never found. The night the ship sank, a farmer just west of Oswego saw a large black dog come to the surface in the waters of Lake Ontario. He said that the dog's back legs appeared to be paralyzed and its fur matted. The dog vanished into the darkness.

According to stories, the Black Dog was seen on other ships that sank, as well. The *Thomas Hume* sank on May 21, 1891, in Lake Michigan. The story goes that the schooner had been sailing along with another ship, the *Rouse Simmons*, when a gale caused the *Rouse Simmons* to turn around and head for a safe harbor. The *Thomas Hume* and its crew vanished into the dark waters. No traces of the ship or crew were found until the vessel was finally discovered in 2005.

The phantom Black Dog also shows up in Michigan folklore, having been seen on the *Issac G. Jenkins* and the *Phoebe Catherine* before they sank, as well.

It only stands to reason that if the black dog shows up on other ships, in other Great Lakes besides Lake Erie, then it is feasible that the animal could have appeared on some of the ships that sank on Lake St. Clair. Some sailors, being a superstitious lot, may not have reported all the sightings of the phantom dog on ships before they ran into trouble and/or sank.

BURNING SHIPS

Another interesting phenomenon reported on the Great Lakes is that of burning ships. Many ships, barges and schooners have caught fire and sunk on the Great Lakes and Lake St. Clair, to be sure. However, some of these ships seem to be reliving their disastrous pasts again and again.

One such burning ship, according to the *Erie Dispatch* in 1867, appears every fall. The story states that sailors and residents of the coast see what appears to be a burning ship out on the horizon. But when vessels go to look for the ship, they find that it was only what they term a "mirage."

There's been some speculation that the phantom ghost ship is that of the steamship *Erie*, which, in 1841, caught fire and burned, claiming approximately 250 lives. For years afterward, and possibly even today, people have reported seeing the glowing lights of the burning ship. This has been observed both from ships that were passing through the area and by people who were onshore. On many occasions, a rescue operation was launched, but when it reached the area where they saw the burning ship, nothing was found.

On Lake St. Clair, it's not unusual in spring, summer and fall to see plumes of smoke on the horizon. Many times, these fires can be attributed to controlled burns on various islands, in Canada or on other plots of land. However, there have been times when the origin of the smoke or fire isn't clear, and in some cases, the blaze vanishes as quickly as it appeared. Could some of these be the fires of ships that once burned and sank on Lake St. Clair and the other waters of the Great Lakes? It's possible.

The Great Lakes Triangle

Everyone's heard of the Bermuda Triangle and the Michigan Triangle on Lake Michigan, but not many people are aware that there's a Great Lakes Triangle, as well. In 1977, aviator Jay Gourley wrote a book called *The Great Lakes Triangle*. In it, Gourley states that the Great Lakes have more unexplained disappearances per unit area than the Bermuda Triangle, which is sixteen times larger than the Great Lakes Triangle.

Gourley says:

> *Because of the irregular shape of the Great Lakes, pilots—aware of the dangers within—ordinarily circumnavigate the lakes, even when overflying might be shorter. It is almost impossible for even the slowest aircraft to be more than 20 minutes from land. Today's airliners can cross Lake Erie through the middle in ten minutes. Faster aircraft can do it in much less than four minutes.…There are hundreds of ground-based, sea-based and air-based radios constantly monitoring emergency frequencies for any sign of trouble.*

While many ships and planes have disappeared over the Great Lakes, following is a list of those that disappeared near Lake St. Clair and the Anchor Bay area.

The Great Lakes Triangle. *Author's collection.*

In November 1913, the ship *The Price* disappeared with all twenty-eight hands on board. There were no survivors; some, but not all, of the bodies were recovered.

In December 1959, an Aero Design 560B disappeared over Lake St. Clair. Two lives were lost.

In March 1966, a twin-engine Piper disappeared close to Lake Huron. Two lives were lost.

Whether these and other planes and ships have disappeared, and whether those disappearances have been caused by storms, fire or something unexplained, is up to you to decide.

8

THE GLOWING TOMB

Back in the day, on a dark and lonely gravel road stood an old cemetery long forgotten by time. While the city or county still maintained it, there hadn't been any new burials for many a moon, and the name of the cemetery is lost except to those who lived in the area at the time.

To pass by it in the daytime, one would barely even take notice of the weathered and worn tombstones that bear witness to the goings-on of passing people and the occasional car. Nor would they notice the abandoned farmhouse that stood next to the cemetery and was purported to be haunted.

However, at night, the cemetery took on a whole new persona; it became mysterious and creepy, all because of a lone tombstone that stood near the side fence at the rear of the graveyard. You see, at night, the tombstone would glow an eerie phosphorous green.

The story circulating at that time through the small town just inland from Anchor Bay is that the farmer who lived in the house next to the cemetery became depressed following a season of bad crops. In addition, his wife had passed away in late summer. Not wanting to go through the rest of his life alone, and facing possible financial ruin because of a failed harvest, the farmer hurled himself off the roof and landed in the cemetery.

Local folklore tells us that he was buried where he landed and that, since his burial, the tombstone put on his grave has glowed green. It's also said that, sometimes, in the night, one can see a dim light flit from room to room through the windows of the old farmhouse.

A friend, Lucy, told me of a memory from when she was twelve and encountered the glowing tomb. Her older cousin and another girl drove her out to see the tombstone one night. As teenagers do, they dared her to go into the graveyard and touch the eerie marker.

Being the type of person who didn't back down from a reasonable dare, Lucy climbed out of the car and scaled the fence to the cemetery. She bravely started to walk toward the tombstone when her cousin took off in the car, leaving her alone on the dark, empty road in the middle of nowhere.

Lucy was never one to give in to fear or flights of fancy, so she decided to give her cousin a good scare in return. She left the cemetery and climbed through a window on the first floor of the old farmhouse. It took her eyes a few minutes to become accustomed to the dimly lit home, the only light being from the moon.

As Lucy looked around the farmhouse, she could tell that it appeared to be a favorite party spot for teenagers—the place was littered with beer bottles, candles and an old mattress. She managed to find a book of matches among the debris and lit one of the candles. Just as she completed that task, she saw her cousin's car pull up in front of the cemetery.

Seizing the opportunity, Lucy began to walk around the house, holding the candle out in front of her. She could hear her cousin calling her name and saw her get out of the car and begin to panic when she couldn't find her and saw the light of the candle in the old farmhouse.

Lucy quickly extinguished the candle and walked out of the back door of the house. Using the cover of darkness, she crept across the dirt road and into the woods by her cousin's car. Her cousin, now in a frenzy, was rushing toward the cemetery gates in a desperate search for Lucy. Seeing her chance, Lucy jumped out from the woods and yelled her cousin's name. Her cousin nearly jumped out of her skin and screamed, sending Lucy into wild peals of laughter. After chastising her cousin for leaving her alone, Lucy got into the car, and she and her cousin returned home. They never spoke of the incident again.

As for the glowing tomb, it's said that someone from a college came out and took small scrapings from the tombstone to see if it had been painted with a glow-in-the-dark paint, but the tests came back negative. The reason the tomb glows green remains a mystery.

To many, this story seems nonsensical or a ruse by adults to keep their teenagers from going out to the area to party and/or get into trouble. Normally, I would agree with the latter theory, but for the presence of a physical object—the tombstone—that gives off a ghastly green glow.

Whether a college or university really tested the stone for phosphorus paint is anyone's guess. It could be just another tale to add to the mystery of the location. However, what if a college did test the stone and no evidence of human interference was detected? What if, for some unknown reason, the tombstone that rests on the grave of the poor farmer really is some type of paranormal phenomenon?

Sorry to say, we'll never know the true answer or the real story behind the glowing tomb, but in some little cemetery in an area that has built up around it, that tombstone is still there. As to whether the grave marker still glows green—that's anyone's guess. However, it's my opinion that it does.

9

MEMPHIS CEMETERY

Legends, folklore, rumors and paranormal activity have swirled around Memphis Cemetery for decades. Most of the stories revolve around one individual tombstone, the "Witch's Ball."

The Witch's Ball is a black marble orb that sits on top of a tombstone at the back of the graveyard and is, by all rights, the stuff of legend. Or is it?

Many people have reported seeing faces in the ball when they are close to it, and the faces have been known to show up in pictures.

There are reports of other types of ghostly activity in the cemetery, as well. Some people have reported seeing full-body apparitions, especially around the Witch's Ball and in the older part of the cemetery. These apparitions have been seen flitting among the tombstones or simply standing by a grave, although it is unknown if the graves they are standing by belong to them. There have also been reports of people thinking they see the ball slowly rotating on its base when they've been in the cemetery late at night.

Some ghost-hunting teams have reported getting EVPs (electronic voice phenomena) in the graveyard, as well. While most of them involve a spirit saying, "Hi" or "Hey," some people say they've gotten EVPs saying, "Don't leave me here" and "I'm alone." It almost makes one feel sorry for those apparently sad or frightened souls that seem to be lost in some way.

However, there are some who say that the faces people are seeing in the Witch's Ball are simply their own reflections, which show up in pictures or when the light hits the ball just right when they are standing next to it. Those ideas are entirely possible.

Others believe that the legend of Memphis Cemetery began when the graveyard was being used as a party spot by bored teenagers. These people think that some adults started the rumor about the cemetery being haunted to discourage the youth from going in there, but it had the reverse effect. Even today, the cemetery is a favorite spot to go if you want to be scared.

So, the debate rages on. Is the Witch's Ball some mysterious orb that shows the faces of spirits, or is it merely reflecting images of the living who want to believe something paranormal is going on? I don't know the answer; it's just one of those things you need to figure out on your own.

10

MORROW ROAD

No paranormal book on the Anchor Bay area is complete unless it includes the legendary Morrow Road. The real story of what, if anything, happened on this road has been lost to time. However, in the many tales woven into the fabric of local folklore, the stories that seem to be the most prevalent revolve around a mother and her young child.

Until rather recently, Morrow Road was a lonely gravel road in a rural area. There weren't many homes on the road; in fact, the area was quite desolate.

While no one appears to be sure when the tragic event on Morrow Road took place, many assume it was in the middle to late 1800s, even though there's no data to support that assumption.

One story says that a mother was home alone with her child during a snowstorm. She put the child to bed and, a little past midnight, went to check on it because she hadn't heard any noises coming from the room.

When she walked into the room, the child's bed was empty. Extremely panicked, the woman frantically began to search the house but could find no sign of her child. She ran outside wearing nothing but her nightgown and froze to death looking for her child. The story goes on to say that her frozen body was discovered four days later, but the child was never found. Several versions of the story have the mother freezing to death while looking for her child.

Another tale says that a young woman had a child out of wedlock and abandoned it under a bridge on Morrow Road. She was so guilt-stricken

that she ran back to retrieve the child, but the baby was gone. In some versions of this story, the mother is so filled with remorse that she searches for years for her missing child until she finally gives up. Some people believe that when she died, she was cursed for what she'd done and her punishment was to forever wander Morrow Road looking for her missing baby. Some stories claim that the mother and young child met with violent and brutal deaths. Still another story has the mother and child perishing in a horrible house fire.

Still other versions of the story say that the child was kidnapped and murdered. When the child's mother went to look for the child, the murderer was lying in wait by the bridge, close to the woman's home, and murdered her, as well.

A story going through the area at some point in history said the mother and child were attacked and killed by Native Americans. One version of this story says that the mother died somewhere near a Native American burial ground in the area. Historically, there haven't been any signs of a Native American burial ground near Morrow Road, although it is entirely possible that Native Americans were in the area at the time these events would have taken place.

People claim that they have heard the sound of a baby crying somewhere in the woods. Others have reported seeing a ghostly woman in a nightgown running down the road screaming, "Where is my baby?" Still others have reported seeing a badly burned woman standing by the side of the road holding the dead, burned body of her baby.

There are even some who claim that if you stop your car and honk your horn three times, you will hear a baby start to cry. Other people claim that they've had bloody handprints slam against the car and window as they drove down certain sections of Morrow Road.

There has also been a bumper crop of stories involving people seeing orbs on the road and around the wooded areas. Some people claim that the orbs seemed to chase them or their vehicles while they were on the road.

In addition, there have been many colors of orbs reported. Some people claim to have seen red orbs, while others report purple, light blue, green and white orbs. From all the reports, it seems that the orbs are showing up in all colors of the rainbow.

While the clear majority of these stories haven't been confirmed, people have reported having paranormal experiences on Morrow Road for many years. There have been so many of these reports that they're hard to ignore.

One local legend does not involve the mother and child. Rather, a Morrow Road monster ate small children and babies. This tale, popular in the 1950s, has fallen out of favor today. Most people believe some variation of the mother and child stories.

Believe it or not, there's an alternate explanation for all the apparent ghostly activity on Morrow Road. One person I spoke with a few years ago informed me that the whole story was a hoax. He said that a bunch of adults got tired of the teenagers going out to Morrow Road and partying, so the adults made up the story of the woman and her child to discourage their kids from going out to the area.

While this may seem like the most logical explanation to many people, it still doesn't explain the number of reports of paranormal activity that have been reported in the last two or three decades. The truth is, not all of those people can be lying. Granted, the local legends and folklore about Morrow Road, the woman and her child have many variations. But with thousands of reports of paranormal activity, something is going on out there.

In the final analysis, it's up to you what you choose to believe, but one shouldn't make up one's mind without first visiting the location and experiencing the mystery of Morrow Road. If you have nothing to do one dark night and feel like having an adventure, Morrow Road may be a good place to start.

11

PROTECTING THE INNOCENT

Some parts of this story were told to me by Marie, the last remaining sister who lived to tell this tale, a few years ago. A couple of months after meeting with her, she passed away. My hope is that her tormented soul has found peace. Other details in this story were related to me by a member of Black River Paranormal, who investigated the home.

Just west of Clay Township, on a lonely dirt road, stands a large, scorched wooden beam surrounded by tall weeds. That's all that's left of a settler's family home after a fire ravaged the farm in the late 1800s. The farmer, his wife and their young daughter, Sarah, all perished in the fire.

Many years after the fire, a home was built on the adjacent lot. The man who built the house, Gus—who from all accounts was an unpleasant character—lived there without incident for about five years before relocating out of the area due to a job change.

Two sisters in their mid-sixties rented the house and got settled in. A couple of years later, Gus passed away, but his family allowed the sisters to continue renting the home.

These two sisters—we'll call them Jane and Marie—in their youth lived rather interesting lives. As with most young people, they experimented with different things and somehow became involved in a satanic cult that was operating somewhere in the South.

In addition, they grew up on farms down South. They saw that farmers were knocking over stones to clear the land for farming. The stones had been placed over Native American graves many years before. They began

to collect these stones and artifacts such as arrowheads, spearheads, feathers and beads. They carefully wrapped the artifacts in tissue paper and kept them in plastic storage bags. Each bag contained a picture of one of the sisters, so they would know who they belonged to.

They'd been collecting them for years, but one of their most prized artifacts looked like some sort of ceremonial hammer, club or tomahawk. They'd found it under the wooden step leading to the porch of one of the homes they'd lived in. The handle was made of wood, and strange symbols were carved into it. Some were hard to make out because the handle was extremely worn. The head of the object was made of stone and was very finely shaped. It had the faint markings of symbols that were difficult to make out.

The sisters' dream was to one day display all the artifacts they'd collected throughout the years or donate them to a museum. As of this writing, the disposition of the artifacts is unknown.

The first thing one noticed on entering the sisters' home was all of the religious items. They were everywhere. Bibles were lying open to various verses, all having to do with protection from Satan; crosses and religious pictures were on all the walls; bowls of sea salt sat on tables; and bottles of holy water sat within easy reach, no matter where you were in the home—even in the bathroom.

The sisters believed that one or more of the demons they worshipped in their youth was still with them in some way, and their greatest fear was that their souls would be damned to hell. While they'd turned over a new leaf and had become devout Christians, Marie once said, "You can make changes in your life, but you can never outrun your past no matter how hard you try." As she spoke, one could see the fear in her blurry blue eyes and regret written across the gentle lines of her face.

When she and her sister moved from the South to this home, they wanted a fresh start—to live out the rest of their lives in peace. Unfortunately, it didn't turn out that way.

A few short weeks after moving into the home, some unseen force began to push them, trying to knock them down. Marie stated that she could feel the presence of the phantom in the room with her right before being shoved. It didn't matter what room they were in, and it didn't happen all the time—but it scared them.

The sisters felt that it was a demon from their past letting them know it was still there and could hurt them in some way anytime it wanted. They'd hoped that by putting out the Bible and bowls of salt, the spirit would be

discouraged from attacking them. While their actions did reduce the number of attacks, they didn't entirely stop the entity from pushing them.

They also complained of having frightening nightmares at least once or twice a month. The one thing the nightmares had in common was that they always had a demonic entity in them, and this entity would threaten them, leaving them to wake up in a fit of terror.

After several months of suffering in silence, the sisters decided they had to do something, so they called in Black River Paranormal to investigate and, hopefully, put an end to their torment.

During the investigation, Black River Paranormal captured some rather interesting EVPs and other evidence that helped explain some of the activity going on in the sisters' house.

One of the most interesting pieces of evidence was the voice of a little girl that showed up on the voice recorder. She called herself Sarah. After a series of questions, Sarah said she used to live "next door."

Knowing there wasn't a home adjacent to the one Black River Paranormal was investigating, one of the investigators walked to the lot next door that, at first glance, appeared to be vacant. Further exploration revealed several large, charred beams that could have been from a cabin. After poking around a little bit, the investigator discovered the remains of an old stone fireplace that, over time, had been engulfed in weeds and underbrush. A little bit of research revealed that a great fire had ravaged the area in the mid-1800s. More questions led her to tell the paranormal investigation team that she was with "Mom" and "Dad." When asked why she and her family were there, Sarah said it was "to protect."

While it's not unusual for a ghost or spirit to take up residence in a nearby home when its house has been destroyed in some way, it is unusual for the spirit to do so after such a long period of time.

Another EVP contained the voice of a man telling Black River Paranormal to "get out." When this recording was played for the sisters, they said it sounded like the voice of their deceased landlord, Gus.

After all the evidence was examined, Black River Paranormal determined that the entity pushing and shoving the two sisters was probably that of their dead landlord, Gus, and not a demonic entity.

They also surmised that the family that died in the cabin so long ago was more than likely hanging around the sisters' home in an attempt to protect them from Gus.

The Black River Paranormal team was particularly disturbed by the Native American artifacts the sisters possessed. If you're a paranormal

investigator reading this story, you probably cringed when you read about them having their pictures in the bags with the artifacts. You're not alone.

There is a theory among some paranormal researchers that by doing this, one is drawing the spirits of these poor souls to them. While the sisters' intent was good—they wanted to save the unmarked stones and the other artifacts from being destroyed—they may have unintentionally disturbed the spirits whose graves they belonged to.

One could argue that the farmers were the ones who disturbed the graves. That's a valid argument, and it may be those farmers who paid a heavy price for disturbing a Native American burial ground. However, it may also be the sisters who kept the artifacts in plastic bags with their pictures inside of them.

Whichever argument makes the most sense to you, all that's really important is whether the souls of those Native Americans are at peace, and that's something we'll never know for sure.

12

THE HAUNTED, HAUNTED HOUSE

Who doesn't enjoy going to a haunted house or barn attraction around Halloween? They are creepy, scary and a lot of fun. But what happens when the "haunted house" is haunted? The haunted house discussed in this chapter is an old barn that has been in existence for many years. It was converted to a haunted barn attraction when a new barn was erected on the property to hold the livestock.

When you walk into the barn, there is a large, open section in the middle that shows off the displays in the loft areas. To each side and along the back are walls that lead into a maze with scary displays around every corner. All in all, it's a good setup; one of the paranormal teams that investigated the haunted attraction reported that it was creepy for them to investigate a place that was set up to be haunted, as some of the displays were quite graphic and ghoulish.

The team was originally called out to the location because patrons of the haunted attraction reported that someone was touching their shoulders or shoving them forward when they were in the maze area, but no one living was around them at the time this happened. Some of this could be attributed to the fact that many of these people anticipated being scared and were already in a high state of anticipation. But other reports are not so easy to dismiss, because some of the people being touched by unseen hands were the ones who run the haunted barn and set up some of the displays.

One room in the barn is used for storage, and there is some storage space up in the loft. In the storage room on the first floor sit two extremely aged

Old church organ, origins unknown. It is known to play by itself even when unplugged. *Author's collection.*

and odd objects: an old church organ and an antique wheelchair. The wheelchair was purchased at an auction, but it's not known by me how the church organ was obtained.

The thing about the old organ is that the playing mechanism hasn't worked in many years, yet, at times, the organ can be heard playing music. At first, people thought it was a trick rigged up by the people who run the haunted barn. But on closer examination, one can clearly see that this isn't the case.

As for the old wheelchair, its mere appearance is creepy enough, but complaints about the uneasy feelings patrons got when in its presence caused it to be pulled from the exhibits and put into the storage room.

Even though there was nothing emitting electricity around the old wheelchair, high electromagnetic fields were detected around it. In the paranormal world, if no logical explanation can be found, it could mean that there is a ghost or spirit attached to or around the object. Since ghosts and spirits are composed of energy, their detection by an electromagnetic measuring device is rather easy.

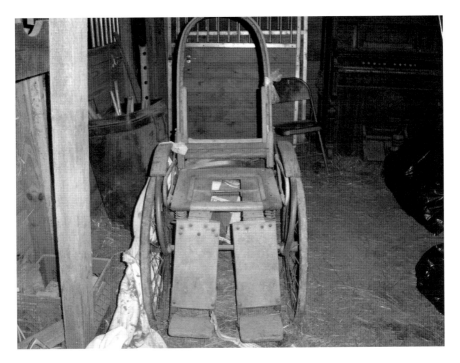

Antique wheelchair. This is not unlike the kind James Hatheway would have used. It kind of makes you wonder, doesn't it? People report feeling uneasy around this chair. *Author's collection.*

Both ghost hunting teams that investigated the haunted barn reported feeling as if they were being followed as they wandered through the maze. A couple of the investigators also said they felt a hand gently grab their shoulder in one part of the exhibit, but they were the only one in the area at the time this happened.

Perhaps one of the most touching paranormal experiences didn't happen in the barn at all. The haunted barn is part of a working farm, and when the investigators were there, it was feeding time for the livestock. The team watched as a young man walked down a path with food for the horses. Behind him walked a white horse waiting to be fed. The thing is, the horse was transparent—the team could see through it.

When told about this, the young man replied that he'd recently had to put down his white horse due to illness. Apparently, his loyal and loving horse is still with him, if only in spirit.

13

HAUNTED SHORTS

This chapter includes stories that are too short to stand alone but too good not to be included in this book.

UNAVENGED DEATHS

Sometime in the late 1950s or early 1960s, a young couple was killed by a hit-and-run driver while walking down a road near the Anchor Bay area. Despite an extremely intensive investigation, the driver of the vehicle was never found.

It's said that every year on the anniversary of their deaths, residents of the homes near where the couple died report paranormal activity that, at times, goes as far as the homeowners being violently attacked. Other activities that have been reported in conjunction with the anniversary of the accident include, but aren't limited to, appliances being turned on or off, toilets flushing when no one is in the bathrooms and water turning on and off in both the kitchen and bathrooms.

From a paranormal perspective, there are a couple of theories that could be at play here. The most probable theory is that this young couple that died so violently are anniversary ghosts. These ghosts show up every year on the anniversary of their deaths. While it's unusual for this type of ghost to be so active and at times violent, it's not unheard of.

The second possibility is that the couple is showing up on the anniversary of their deaths to remind people that their case hasn't been solved yet and they are seeking justice. These types of spirits are sometimes referred to as avengers. Avengers are here for one of two reasons: either they are out to seek revenge against someone who they believe wronged them in life, or they are out to right a wrong. In other words, they want justice.

In this case, this theory makes a lot of sense. The tragic deaths of this young couple, and the fact that their murderer was never brought to justice, would be enough to keep the spirits of this couple showing up year after year until the person who ran them over is caught and brought to justice. After that happens, it's unlikely that the ghostly couple would ever be seen again.

Home, Not So Sweet Home

Doug and Carmen were thrilled to be able to find the perfect home to rent close to Lake St. Clair. They were new to the area and were excited about Doug's new job at an automotive company. It was a fresh start for the couple who had, just a few months before, faced an uncertain future when Doug lost his job. They'd spent the last nine months living with Doug's parents while they saved up enough money to get a place of their own.

They moved in, and Carmen spent the next few days cleaning and unpacking. They'd purchased a few new pieces of furniture, and the home was shaping up nicely. However, within a few days, the couple realized something was terribly wrong with their new home. It was haunted.

There were a few times when the smell of cigar smoke would waft through the house, but it was strongest in the living room. Doug didn't smoke. In addition, Carmen would on occasion walk into the kitchen and find a drawer or a cabinet door open. At first, she thought she was just being forgetful and leaving them open herself, but one day when she was in the kitchen unloading the dishwasher she saw one of the cabinet doors she'd just opened to put away some dishes slam so hard it made her jump. She quickly finished her chore and left the kitchen. She sat on the couch, almost afraid to move, until Doug came home from work. She told him about the things she'd experienced, but he dismissed her claims, saying that it was just her imagination. But Carmen knew better.

She talked to the landlord and learned that the previous tenant, who'd lived in the home for years, was an older gentleman, a veteran, who had

died in the home a couple of months before they rented it. He'd been a good tenant, the landlord said, and liked things orderly. The landlord also told her that it had taken several good cleanings, including washing the walls, installing new carpeting and buying new window treatments, to get rid of the cigar smoke from the previous tenant.

She told Doug about her conversation with the landlord, and Doug finally admitted that he had smelled the cigar smoke but didn't want to admit it because he was afraid Carmen would be freaked out.

Once Carmen realized the ghost haunting her house was that of the old tenant, and that it probably meant her no harm, she relaxed, and the couple got used to sharing the space with the spirit.

Luke the Spook

Romeo Plank Road in Clinton Township is home to the mysterious local legend of Luke the Spook. There are two possible explanations for the mysterious light that is seen on this road late at night.

Local folklore states that there was a Dr. Lucas who was traveling down that road late at night in the late 1800s. He was coming home from a late-night call when his horse and buggy missed the bridge. He was killed in the accident. There are some reports of people seeing an old-fashioned buggy winding its way through the trees. It is speculated that the light that is seen belongs to the lantern that would have been hung on the buggy at that time.

Another story tells of a railroad worker who was killed in that area in the late 1800s. It's said that he still walks the road with his lantern, guiding people to safety in the dark.

One woman, Marie, remembers her experience as a teenager involving Romeo Plank Road. She and a couple of her friends had heard the story and wanted to check it out for themselves. At that time, Romeo Plank Road and the area around it was still rather rural, not the built-up region it is today.

Late one hot, summer night, the girls slowly drove down Romeo Plank Road, their eyes open for any sign of the mysterious light or the phantom horse and buggy. Their first pass at the road didn't yield any results, so the girls turned around and proceeded slowly back down the road.

While many people have had experiences on Romeo Plank Road in which they believe they encountered Luke, the following is one of the most intriguing.

Out of the darkness on the side of the road, Marie and her friends saw a dim light swaying slowly back and forth, as if it was being carried. Marie stopped the car, and they peered into the darkness to see if they could see anything that could explain the light. Just then, Marie said they heard what sounded like the "clomp, clomp" of horse hooves hitting the ground, coming from the direction of the light. The girls became frightened, and Marie quickly put the car in gear and sped off into the night. She never forgot her encounter with what she believes was Luke the Spook.

PUTTYGUT BRIDGE

The story of Puttygut Bridge is as shrouded in mystery as the events that allegedly took place there. No one is quite sure how far back in time the tale goes, but there is one thing most people agree on: the bridge is haunted.

The story goes that a man, who may or may not have been intoxicated, drove his truck off the bridge when the Belle River was flooded. The man was never found and, according to most accounts, never seen again.

Some people say that if you go to the bridge late at night and turn your car off and open the windows, you will hear the eerie sound of a vehicle hitting the water and the man who was in the vehicle will appear in front of your car. Some people say that you should put your keys on the car's roof when you stop at the bridge. Other people state that they've heard that story, as well, but don't believe it's a good idea to put your keys outside the vehicle.

There have been reports of people hearing the splash and then seeing something coming out of the water, but they are unable to identify exactly what it is. They can only say that it looked like a mysterious light of some kind.

Others have reported seeing a light they can't explain on the road coming toward them and then disappearing. Several people have tried to duplicate this light in many ways but, as of this writing, haven't been able to, according to the reports I have read and heard about.

Several paranormal teams have gone out to Puttygut Bridge and conducted investigations. They report that a shadowy figure of a man shows up in photographs and say that they have heard the splash of a vehicle, even though the river was almost dry at the time one team visited the site.

A couple of the paranormal teams also reported seeing the mysterious light but couldn't find a rational explanation for it.

There are many unanswered questions when it comes to this particular haunt. Is the ghost of the man who drove off the bridge haunting Puttygut Road? Is the activity a lot of people are experiencing merely residual energy (an event replaying itself over and over like a tape on a loop)? What is the cause of the mysterious light that so many people have seen?

These questions may never be answered, but this seemingly harmless haunt may be an interesting place to visit and/or investigate to try to get to the truth.

14

UNSEEN RESIDENT

Living in a haunted house can be an interesting experience. At times, homeowners may be terrified; at other times, they are amused; and at still other times, they are bewildered. The one certain thing about living in a haunted house is that it's not boring. One never knows what the ghost or spirit that has taken up residence is going to do next.

Such is the case with a historic house that stands on a nice street south of Algonac. The homeowners, Jim, Carol and their family, have been living with a rather active ghost for many years.

Because the home was built in the mid-1800s, it's changed hands several times. It is almost impossible to determine if the spirit is that of one of the previous owners.

The general consensus among the family is that there is more than one spirit in the home, but they all agree that the main, or most powerful, ghost is that of a man. The other spirit is believed to be that of a small child, and the family is prone to think it is a little girl. The antique rocking horse in the dining room will rock back and forth from time to time as if a child is playing on it.

However, the spirit that is the most active is that of the man. Sometimes, it appears as a dark shadow in different rooms of the house. It is not a shadow person, because it doesn't flee, as shadow people normally do once they've been spotted. However, the family reported that, at times, they have witnessed more than one shadowy figure in a room. The family feels it's as if the spirit wants them to know it's there. It may even be an attempt to

intimidate the family in some way. The family has reported that the male spirit has tried to intimidate them in the past and continues to do so using various methods.

For example, it wasn't until recently that Jim and Carol's children, who have long since moved out and have families of their own, told their parents that the entire time they lived in the house they were afraid to go upstairs alone. They would wait until their parents went up to bed or would go upstairs together, but they would be almost paralyzed with fear. This fear was so great that if one of them had to use the bathroom in the middle of the night, they would wake up their sibling to go with them, because they didn't want to be alone.

While they couldn't pinpoint any experience that caused them to be afraid of the upstairs, other than occasionally hearing footsteps walking up and down the hallway some nights, they reported that even to this day they have the fear of going upstairs by themselves. All they could say is that they felt like there was something ominous up there and they were filled with feelings of dread when they knew they had to go upstairs. Their parents don't appear to be bothered by the second floor of the home, but they don't discount the feelings their children have in that area of the house.

The second floor is not the only place in the house that has its share of paranormal activity. The first floor appears to be another favorite spot for the spirits to hang out. The family has reported that the door leading outside from the dining room will open and close by itself and lights will go on and off by themselves.

On one occasion, the gas stove was left on, although it's unclear whether it was a living person or the ghost who turned the gas on in the first place. Carol opened the dining room door to air out the house after turning the gas off and returned to the kitchen. When she returned to the dining room a few minutes later, the outside door was closed. Carol was the only one home at the time, so there appears to be no logical explanation for this. The door is rather heavy and opens into the room, not toward the outside, so it couldn't have been the wind that blew it shut. There have been other times when the dining room door was either opened when closed or closed when someone in the family has left it open.

Another time, one of the family members was in the living room and a disembodied male voice told her to "go home."

The family members have also reported feeling as if someone is standing at the sink when they walk into the kitchen. On a few occasions, it felt as if someone was standing next to them at the sink.

Quite recently, one of the ghosts or spirits has learned how to use a cellphone. On one occasion, Carol's cellphone was sitting on the end table next to her when a voice started coming out of the phone, saying, "I am here." It repeated this phrase for a period of a few minutes before finally stopping. Another time, a voice that came out of the phone said, "Come find me."

These events shook up Jim and Carol a bit, but in a way, they also found it amusing. They feel that the ghosts or spirits like to interact with the world of the living and will use almost any means at their disposal to do so.

Over the years, the family has become accustomed to the paranormal activity in their home; while some of it may startle them at times, they refuse to give in to the fear and move. Jim and Carol are quite content with their ghostly roommates and can't help but wonder what the ghost or spirits are going to come up with next.

THE DARK MAN

On a quiet dirt road between New Haven and Richmond, a small house once stood. The elderly man who had lived in the house had long since passed away, and the house was left to rot with all his possessions inside. Urban explorers would frequently break into the house to rifle through the remnants of the old man's life or to party.

After hearing a few tales about the house, a local paranormal team started to take an interest in the home and set out to do an investigation.

Because the home had no electricity, investigators couldn't use some of their equipment, so they decided to go "old school" and use only their video camera, tape recorders and EMF detectors. The team had tried to contact the relatives of the man who used to live there to get permission, with no success. The next best thing was to stop by the police station and inform the police where they were going and how long they were going to be there before heading out to the house.

Upon arrival, they noticed something immediately, something they normally don't experience before starting an investigation—they felt a sense of foreboding. The team members discussed this feeling among themselves; during that discussion, one team member said he felt like they were being watched.

Team members first walked around the perimeter of the house to ascertain points of entry and exit. They noticed that the tiny house was in

horrible condition and that they'd have to watch every step while inside. Tall weeds and vines had almost completely engulfed one side of the house and were well on their way to making the entire home disappear.

It was just past dusk when the team entered the home through the front door; the last light of day made it easier for their eyes to adjust to the impending darkness. The living room was small and cramped. Old furniture, now home to field mice, sat against the back wall, and a beat-up dining table and two chairs sat just to the right of the door. There were papers, clothes, beer bottles and other items scattered everywhere. The four investigators, James, Matt, David and Jeff, were just a few steps into the home when the front door slammed behind them. The startled team whirled around, and Jeff ran to the door to make sure it opened. Assuming it was just the wind, they moved forward through the house.

The kitchen smelled of decaying food, and no one on the team even dared to open the refrigerator. Canned food still sat on cabinet shelves, and broken dishes and old newspapers littered the floor. As they walked through the rubble, field mice raced out from under the debris to get out of investigators' way.

In the bedroom, the mice had made quite a mess of the mattress, tearing it apart for nesting material. What remained of the mattress was soiled with mice feces; the odor was almost overwhelming. As they turned around to leave the bedroom, a hulking dark shadow blocked their exit. Thinking it was one of the urban explorers, Matt shined his flashlight toward the door, but his light went right through the shadow.

The investigators then realized that they were dealing with a shadow person, or some type of entity that hadn't fully materialized. They started talking to the phantom, telling it that they meant no disrespect and were sorry about the condition of the house. Within a minute or two, the dark shadow vanished, allowing the investigators to get out of the room. They headed back into the living room to discuss what had happened. They all pretty much agreed that the dark shadow figure was the ghost of the man who had died there, and they spent the better part of two hours investigating and trying to contact the spirit, but to no avail. The house had gone deadly silent.

The team members packed up their equipment and exited the house through the front door. As they were backing out of the driveway, they looked at the house one more time and saw the dark shadow man watching them from one of the windows. They debated about going back in but decided against it. The team members decided to let the ghost of the former occupant be in peace.

15

THE HAUNTED RESTAURANT

North of Anchor Bay is one of many popular restaurants frequented by locals and visiting boaters alike. The one thing that sets this restaurant apart from some of the others is the fact that it is haunted. Two paranormal groups have been called in on two occasions to conduct investigations, and their results have been rather interesting.

But first, let's look at what prompted the manager of the restaurant to contact a paranormal investigation team in the first place.

There were reports of a full-body apparition showing up in the kitchen of the restaurant, scaring the employees. It's believed the phantom was that of a cook who used to work at the establishment but whose life was cut short when he was still quite young.

Other employees stated that napkins and other objects were dropped on them, sometimes when they were walking in or out of the kitchen. They are all in agreement that this activity may be attributed to one of the managers who worked there a long time ago and who is now deceased. It's also widely believed that the spirit of the original owner of the bar, who is also deceased, still hangs out at the bar as he did when he was alive.

Some of the patrons of the restaurant have also reported seeing a dark, shadowy figure of a man hanging out in the hallway by the bathrooms. At first, they thought it was their own shadow they were seeing, but then they realized that the shadow was stationary while they themselves were moving.

According to the reports by both paranormal investigation teams, the kitchen seemed to be the most active area, followed closely by the dining

room. One of the teams reported that they set up a laser grid in the kitchen. A laser grid is a laser beam that forms a grid pattern on the walls or any other surface. If anything breaches the laser beam, the shape of the person or object that interrupted the pattern will show up as a void.

Upon reviewing the tape, they discovered that a large, human-shaped form breached the laser several times in the kitchen, but the night-vision camera clearly showed that there wasn't a living person in the kitchen at the time the breaches occurred. This would lead one to the conclusion that a ghost or spirit in human form was walking through the kitchen at those times.

One of the female investigators took a break to use the restroom. She reported feeling uncomfortable in the hallway that led to the bathroom. She felt as if she was being watched, but there was no one there that she could see. Entering the women's bathroom, she reported that she felt as if she wasn't alone, and while she was using the restroom, the electric hand dryer started to run. She knew she was alone, because she would have heard anyone who came into the restroom. She quickly rushed out to the sink area,

The kitchen where a full-body apparition has been spotted. It scares the daylights out of restaurant personnel. *Author's collection.*

but no one was there. She asked the rest of the team if anyone had entered the restroom; given that the rest of the team members were men, the answer of course was "no."

Both paranormal teams experienced not only equipment malfunctions but also the batteries draining in their devices at very rapid rates. Since the equipment was checked and found to be working perfectly before the investigations and the batteries were all either freshly charged or brand new, the only conclusion is that one or more ghosts or spirits were draining the batteries.

This phenomenon is quite common when a ghost or spirit is present and generally means that the entity is sucking the energy out of the batteries so that they can either manifest or use the energy to cause some type of paranormal event. One of the paranormal teams has an investigator who, at times, is able to cross over ghosts or spirits to the other side. Using a pendulum, she was able to determine that this spirit did want to cross over to the other side, and she was able to help him do that.

As for the other spirits that still reside in the restaurant, at last report they were behaving themselves. And since no one feels threatened by them, as far as anyone knows, they are still there.

16

CRYPTIDS AND OTHER STRANGE CREATURES

Cryptozoology is a fascinating subject. Heated discussions occur around dinner tables as to whether cryptids really exist. By definition, cryptozoology is classified as a pseudoscience. It assumes the existence of certain plants and animals that come from folklore, legends, witness sightings and other sources that mainstream science considers insufficient.

While biologists are always discovering new species, people who call themselves cryptozoologists tend to focus on animals and other things that are mentioned in folklore or mythology.

Michigan is not without its share of mysterious cryptid creatures, and here is a sampling of them as they pertain to the Anchor Bay area and just beyond.

DOGMAN OF MICHIGAN

The first report of the Dogman was recorded in Wexford County in 1887, when it was spotted by two lumberjacks. However, it's widely believed that the legend of this creature goes as far back as to when the Odawa tribes lived in the area. While most of the sightings have been in the northwestern part of the lower peninsula, there have been sightings in other areas, as well.

In 1937, a man claimed that he was attacked by a pack of five dogs, one of them walking on two legs. Other reports have been made in Allegan County in the 1950s and again in Manistee and Cross Village in 1967.

According to the legend, the Dogman of Michigan appears in a ten-year cycle, although the reason for this isn't exactly known.

The Dogman of Michigan is described as standing approximately seven feet tall with the torso of a man and the head and the rest of the body being a cross between human and canine. It's been described as having either blue or amber eyes. It's also said that it has an eerie howl that sounds somewhat like a human scream. There have been sightings of it walking on two legs like a human and on four legs like a dog, although most people who've witnessed this creature say it doesn't appear to move like a dog.

Most people had not even heard of the Dogman until one hundred years after the first recorded sighting. It all started with a song that DJ Steve Cook recorded for April Fools' Day about legends. When he first wrote and recorded the song sometime around 1987, he'd not heard of the Dogman. After the song aired, reports started pouring into the radio station, WTCM, of Dogman sightings. Since then, the Dogman has become part of the mainstream as far as legends and folklore in Michigan. The creature was even featured on an episode of *Monster Quest* in 2010.

A rather cryptic report of the Dogman of Michigan was reported recently to *Cryptozoology News*. According to the report, a man, his son and a friend were in the woods in Ira Township, by the shores of Lake St. Clair, when the Dogman just showed up. They said it was walking on all fours but not like a dog. They said it had black fur. They got only a glimpse of it, but they described it as something they'd never seen before.

The problem with cryptid creatures such as the Dogman of Michigan is that many sightings go unreported, because some people are afraid no one will believe them or that they will be ridiculed. However, it's been my experience that where there's smoke, there's generally fire. There's no way to know for sure if the Dogman actually exists, but there's also no way to know for sure that it doesn't.

THE MISHEBESHU

An Objibwe tale speaks of a water monster called the Mishebeshu ("great lynx"). It's also known by the name Gichi-anami'e bizhiw, which means "the fabulous night panther." While spotted mostly in the northern Lake Huron region, this creature is said to have a den by the mouth of the Serpent River, better known today as the St. Clair River, which flows into Lake Huron.

According to legend, the panther that lives under the water is said to have the body of a feline, the horns of a deer, upright scales on its back and, depending on which story you believe, a very long tail. In some legends, the tail is more serpentine than in other stories that have been told about this mysterious creature.

It's believed that this creature lives in the deepest waters of the lakes and rivers near Lake Huron and can cause severe storms. While some stories depict the sea panther as being helpful and protective, other tales describe it as a malevolent beast bringing death and bad luck. Yet others believe its purpose was at one time to protect the copper of that region of Michigan.

It's also believed that, to ensure safe passage through the lake, the creature needs to be placated in some way. As recently as the 1950s, the Prairie Band of Potawatomi performed a ceremony to calm the creature and help maintain balance between the underwater panther whose domain was the lakes and the Thunderbird, whose domain is the air and sky.

During the copper rush in the 1840s, many accidents and shipwrecks occurred, and some people attribute them to the wrath of the Mishebeshu. The underwater panther is also thought by some to be responsible for the sinking of the steamer *Cumberland* and the ship *Algoma*, which sank during a storm in 1855, taking forty-five people to their deaths in the underwater den of this mysterious creature.

Bigfoot

Reports of Bigfoot in the Lake St. Clair region date to the 1860s, so it should be no surprise that there are still sightings of this creature in the area. However, due to the increase in the population between then and now, Bigfoot sightings in the Anchor Bay area have dwindled considerably. In fact, the last reported sighting was in 1988.

In that instance, three people were deer hunting in St. Clair County when they heard something walking through the woods and a high-pitched scream. At the time, they believed they may have been stalked to within twenty yards or so.

Another scream was followed by the sound of a tree falling and something large running through the underbrush. Whatever it was is thought to have been so heavy that the people claim they could hear the sound of its feet hitting the ground. Looking around, they discovered a tree, six to eight

inches in diameter, snapped in half about eight feet off the ground. While they were camping that night, they saw a large shadowy figure just outside the range of the flashlight.

About a week later in the same general area, someone reported seeing a large animal with black hair and yellowish eyes in a squatting position using its hands to steady itself. Some people claim that Bigfoot has been seen around their farms and livestock, perhaps looking for an easy meal.

It's hard to say if there have been more sightings than what has been reported; many people don't want to admit seeing Bigfoot. It's possible that in some of the remaining densely wooded areas of the Anchor Bay and St. Clair areas, there have been other sightings of this elusive creature.

EPILOGUE

I sincerely hope you've enjoyed our ghostly historical walk through the Anchor Bay and Lake St. Clair area of Michigan. It was an honor—and a whole lot of fun—putting it all together for you.

As I worked on researching and writing this book, I couldn't help but think back on all the wonderful—and sometimes scary—experiences I've had in my encounters with the paranormal. One thing's for sure: it's always been interesting. I've had the privilege of working with and meeting some amazing people who work so hard to advance the paranormal field.

Whether we realize it or not, history plays a great part in our lives, and the people who came before us have, in their own way, contributed to what makes the Anchor Bay/Lake St. Clair area such a wonderful place in which to work and live. Perhaps so much so that some of the ghostly inhabitants that appeared in these stories, and stories still untold, have decided they aren't ready to leave the earthly realm and cross over to the other side. They have chosen, for whatever reason, to remain among the living—much to our delight or displeasure, depending on your point of view.

Mainstream science has made great strides the last few years to catch up with what most paranormal investigators already believe: that death is only the beginning.

For example, neuroscientists have said publicly that they know that our consciousness, or soul, survives death. They just haven't been able to measure for how long. Does this prove the existence of ghosts and spirits? That's not for me to say. You'll have to make up your own mind.

Additionally, scientists at Oxford University have made a startling breakthrough in quantum physics. The team from Oxford, led by Dr. David Deutsch, shows that mathematically, parallel universes are real, not just the thing of science fiction. This could mean that when we die, our consciousness, or soul, goes into a parallel universe. If that's true, then one would have to surmise that it's possible for our reality and the parallel reality to intertwine and overlap, allowing us into their world and them into ours. It's long been believed that the world of the living and the world of the dead are most likely to intersect during the fall equinox. This phenomenon, in some religions, is called the "thinning of the veil." Simply put, there's something about the way the earth tilts during the fall equinox that thins out the wall between the living and the dead; this veil is the thinnest around the end of October.

There are so many new and exciting things happening in the world of science and the paranormal. I won't even pretend to have the answers, but it sure is fascinating to think about.

The truth is, there is so much in this world we don't yet know, and yet, many people fear things they don't know about or understand as much as they fear ghosts and spirits. One of my main goals in writing this book is to help people understand that most ghosts and spirits are like us, just in a different form. The majority of them were once living human beings. If one thinks about ghosts and spirits in these terms, one may realize that there's really nothing to fear. I hope I've helped you better understand their world and their reality.

By now you might be wondering what you should do if you think your house is haunted. Here's what I tell all of my clients:

1. *Don't panic and try not to show fear. Showing fear can make some types of entities more powerful.*
2. *Look for a logical explanation for what just happened.*
3. *Keep a journal of all paranormal activity. Include such things as exactly what happened, the time of day, the weather at the time the incident occurred, who was present, how the incident made everyone feel and any other information you or the people who witnessed the event feel is relevant. It's important to be proactive, not reactive.*
4. *Research the history of your home or business. Find out who lived there and who died either in the home or while living there. This information could help you figure out who the ghost or spirit is that's haunting your house.*

5. *If you're at all religious, or if you think it will make you feel better, have your home blessed by a clergy member. Contrary to what many people believe, a priest is not the only member of the clergy qualified to bless a space.*

6. *If the haunting becomes violent, it's time to call in a qualified paranormal investigator to help you handle the situation. By "violent," I mean, if the ghost or spirit is biting, scratching, punching, pushing or throwing objects. In addition, if you hear scratching on the walls, something growling or making other threatening sounds, you should seek help as soon as possible.*

7. *Trust your instincts. If every fiber of your being is screaming at you to run, then, by all means, run and fight another day. The safety of you and your family is paramount.*

8. *Don't feel that you are all alone and that no one will understand or believe what you're going through. Don't live in silent terror or fear. Help is available. There are people who will believe you and help you through this difficult time.*

Remember, unless the ghost or spirit is being violent, most entities are generally harmless and aren't out to hurt anyone. In some cases, they don't mean to scare anyone but are looking for a way to communicate. Others might be trying to deliver a message or simply returning to the home or place they loved when they were alive.

Being able to see and communicate with spirits my whole life has given me a unique perspective into the spirit realm, and there's hardly a day that goes by that I don't come into contact with at least one ghost or spirit. It's kind of weird, I know, but weird is pretty much my normal, and it seems to work for me.

My hope is that the stories in this book gave you something to take away with you when you've finished it. Whether it's a lesson or just pure enjoyment, my goal was to make you think or give you a new way of looking at the world of the paranormal.

I want to thank everyone who shared their stories and experiences with me in order to make this book possible. Your courage and willingness to tell your stories are greatly appreciated.

As always, I'd love to hear about your experiences with the paranormal and answer any questions. And if you just have a comment or thought to share with me, you can email me at: debichestnut@yahoo.com. I do answer all my emails.

So, the next time you hear footsteps in the hallway of your home in the dead of night, or something unseen whispers in your ear while you are sleeping, or someone touches you on your shoulder when there's no one else around, maybe you'll think about the stories in this book and not freak out too much.

Until next time, my friends…sleep tight.

BIBLIOGRAPHY

Archdiocese of Detroit Media Advisory, November 9, 1995.

Before It's News. "The Legend of Morrow Road: A Haunting in Algonac, Michigan." http://www.beforeitsnews.com.

Dark Destinations. http://www.darkdestinations.blogspot.com.

Detroit Free Press, September 21, 1921, 5.

Donahue, James. "Lake Erie's Legendary Monsters of Shipwreck." http://perdurabo10.tripod.com/galleryh/id13.html.

Gonyeau, Richard. "Indians Came Here to Bury Their Dead." *Anchor Bay Beacon*, December 23, 1983.

———. "Pottery, Bones Tell Story of Early Indians." *Anchor Bay Beacon*, January 4, 1984.

Great Lakes Shipwrecks. http://boatnerd.com/swayze/shipwreck/s.htm.

Harrison Township Historical Society. Highlights from the Second Educational Presentation. May 10, 1995. Harrison Township, Michigan. http://www.harrison-township.org/residents/historical_society/docs/lostcities.pdf.

Lake St. Clair Network. "History." http://www.lakestclair.net/index.php?/page/About/history.

True Northerner, April 22, 1881, 5.

About the Author

Debi Chestnut is a northern girl with a wicked imagination and a passion for adventure, especially when it comes to exploring historical and/or haunted locations. She has written several books on the paranormal. Debi is active in the community and conducts speaking engagements, radio shows and workshops on the paranormal. Debi is also working on future books to share with her readers. She resides in the Anchor Bay area of Michigan with her husband, dog and two cats.